ENGRAVERS

two

above: Peter Bosteels
front cover: Peter Forster, from *The Rape of the Lock* (Folio Society)
back cover: Landscapes by Jeroen van Duyn and E. N. Ellis

Andrew Davidson: from *The Iron Man* Faber & Faber

ENGRAVERS
two

A HANDBOOK COMPILED FOR
THE SOCIETY OF WOOD ENGRAVERS

SIMON BRETT

SILENT BOOKS

First published in Great Britain 1992
by Silent Books, Swavesey, Cambridge CB4 5RA

ISBN 1 85183 038 3

Typeset by Action Typesetting Ltd
Printed in Great Britain by
Redwood Press Ltd, Melksham, Wiltshire

All engravings are reproduced actual size,
unless otherwise indicated.

ALL THE ARTISTS
IN THIS HANDBOOK
MAY BE CONTACTED THROUGH
THE SOCIETY OF WOOD ENGRAVERS
0672 512905 or 081 940 3553
or at the address below

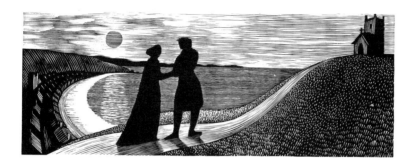

The Society of Wood Engravers is primarily an artists' exhibiting society of some seventy members, who are invited or elected to membership on merit. There is a wider support group of subscribers, to which anyone may belong on payment of the annual subscription. The Society, which was founded in 1920 by Robert Gibbings, Lucien Pissarro, Gwen Raverat, Edward Gordon Craig, Eric Gill and others, exists to encourage the practice of relief printmaking and of wood engraving in particular. Modestly run, its principal regular activities are a newsletter for its artists and for any collector, enthusiast or member of the general public who subscribes; and an annual exhibition. The newsletter goes all over the world and is sometimes the only way engravers have of being in touch with each other. The exhibition, selected from an open entry and with no privileges in the selection for the members, tours some half dozen galleries between September and June each year.

For details of the Society, subscription, submission to its exhibitions or contact with individual artists, please apply to

The Honorary Secretary, The Society of Wood Engravers,
P.O. Box 355, Richmond, Surrey TW10 6LE, England
081 940 3553

engraving: Harry Brockway

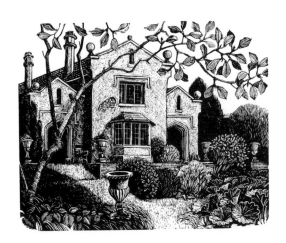

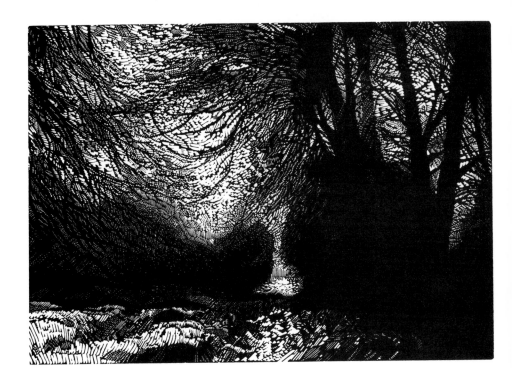

Claire Dalby
Colin Paynton

INTRODUCTION

The aims of this book when first published were to put into permanent record a new generation of wood engravers, to present work by a range of currently active engravers to the public and to the editors and art directors whose perception and use of the medium can so critically affect its future, and therefore also to affect that perception.

In this new edition, most of the visual material has been substantially revised, and among the new artists included are a number of American and Canadian engravers. Their work seems to derive more directly from the trade engravers of the nineteenth century than that of their British counterparts and less from the reactive modernism of the 1920s or the Bewick revival. Their subject matter seems to have a freshness which is independent of either of those sources.

An art which deals only with limited areas of subject matter is in danger of becoming or remaining a minor art. The present revival of interest in wood engraving, which began in the 1980s, has pushed the medium in several new directions both technically and expressively. The American and Canadian artists offer a welcome extension of these examples. Nonetheless, the employment of engravers is still less adventurous than it might be, still characterised by fur, feather and foliage – by subject matter – more than by any recognition of the qualities of the medium itself, its crisp black and white, its melting tones. It is not always easy to distinguish these formal elements from the subject matter in which they are embodied, particularly in the case of that endlessly varied response to the natural world which is, as it were, the vernacular of British wood engraving, and will probably remain so as long as the name of Bewick is remembered. For a number of artists this is their personal and proper field of expression; and it is, after all, the full, expressed personality of a given artist which the collector buys or a publisher chooses to employ. But the medium may have more potential than some of the messages convey.

As a means of self-expression, wood engraving has been described (by Peter Forster) as 'just about as spontaneous as making a soufflé'. Physically, it is the simplest of printmaking methods, but few in any

generation are drawn to it, which is more a matter of temperamental affinity than of difficulty; so, though not necessarily a minor art, it has tended to be a minority one. About forty artists were represented in the first edition of *Engravers*, about seventy in this, but there are still very few practitioners. Of those in this book, only a handful do it full-time. Most, like most artists, have other jobs, and some would describe themselves as amateurs. It would be unrealistic and unfair to issue some challenge for the expansion of wood engraving to each of these individuals regardless of their circumstances and commitment. Nonetheless, if the soufflé does not rise, it will fall. If only the line from Bewick is trod, only narrowly, it will peter out. If no one expands the range of experience with which an art form deals, it will ossify or dwindle; and in such a small field as engraving is, the contribution of those who can rejuvenate is disproportionately important.

The work of younger artists, newly included in this new edition, and that of several new members of the Society of Wood Engravers, excitingly meets this challenge. We continue to urge it, by these examples of their work, upon those who determine how engraving shall be used and how engravers are employed. There is a self-aware, eclectic expertise among the younger artists which is completely of today, while older generations are at their peak, some having arrived there almost unnoticed under the long (and distinguished) shadow of the 1920s and '30s. Engraving at the end of the twentieth century is pursued by more generations of artists than ever before, without being dominated by any one of them.

This handbook includes artists still in their twenties and others who were born within the first dozen years of the century and are still active contributors and exhibitors. The older engravers appeared in *British Wood Engraving of the Twentieth Century* by Albert Garrett, which was the last substantial survey, published in 1980 but based on material gathered in the early seventies; but they were not recognised there as having a distinct identity of their own, different from that of the inter-war generations, on whom Garrett appropriately concentrated. His book has a valedictory tone, for he could not see, at the time of writing it, any hope of a renaissance. Both editions of this present book have been compiled by inviting members of the Society of Wood Engravers to contribute to a volume emphasising 'younger and currently active' artists. 1920 emerged as a watershed birth-date between Garrett's artists – whose place in history is well documented, and not only by him – and these. One or two artists have been included who are not or who have ceased to be members

of the Society, but without whom the historical record would be incomplete; not all wood engravers belong to the Society; and some declined the invitation.

Wood engraving stands at its familiar crossroads between printmaking and illustration: between having been recently saved from extinction by, once again, graphic and illustrational applications, and never quite having achieved the independent life which the inter-war period seemed to promise, but which the Second World War devastatingly interrupted. To urge those with commissions to free artists from stereotyped subject matter, or to favour the independent print which hardly earns them a living, is an old plea which points to a larger question: whether engraving may one day become a medium which any artist – not just any graphic artist – might employ, as painting and sculpture are. History (not helped by educational policies) seems as determined to cheat it of this ordinary heritage as it is to short-circuit the influence of the handful of important twentieth-century artists who have been attracted to the medium.

Invented in the 1820s, wood engraving had to wait until the 1920s to resume its identity as a medium used by an artist for his own expressive purposes. It was exploited by the reproductive engravers of the nineteenth-century to such an extent and with such formidable technique that all twentieth century practice has appeared as a series of reactions and revivals by comparison. The initial and major reaction was against the soul-destroying skill of the nineteenth century, in favour of direct artistic expression. The revivals have been, first, of Thomas Bewick's original 'white-line' approach; then, of boldness and, in its turn, of finesse; and, finally, of reproductive engraving techniques themselves, though on a different scale. Above all, there are periodic lapses and revivals of interest in relief printmaking as such, as it appears to 'stand for' different values at different times; and in particular, there has been fluctuating interest in relief printmaking on a fine scale.

'Relief printmaking on a fine scale' is a cumbersome phrase, but it is almost more informative than 'wood engraving' to describe the work in this book. To start with, several of the engravings in the book were not done on wood but on synthetic materials; but, though they are not here printed from the blocks but are photographically reproduced, the images can only be created in this one way: *a flat surface is engraved* into 'relief', and the result is *printed*. The word 'relief' is definitive, because the *way* the engraving is printed determines the nature of the image. Secondly, the fine scale is definitive because it distinguishes this work from other sorts

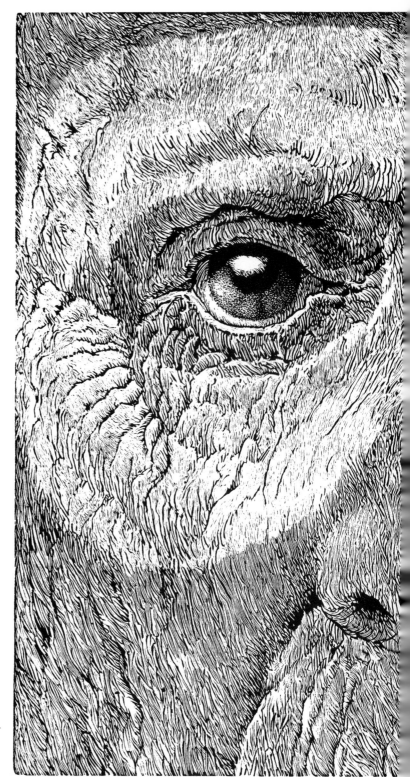

Jim Westergard:
The Lone Ranger
(retired)

See page 78

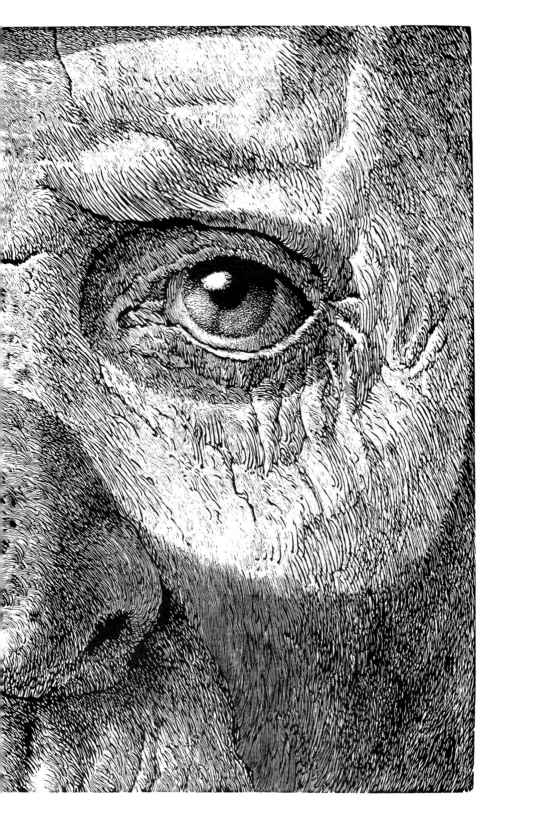

of relief printmaking. The small size of the tools it is done with and the fine texture of the materials it is done on – classically, but by no means exclusively, boxwood – determine the kind of visual attention an engraving commands, and its size. An artist may 'obey' this tendency to small size or react against it, but beyond a certain size, he inevitably commands a different sort of attention and finds himself making a different sort of print. That is a natural transition which many of the artists represented here have also made.

Because this is the only way to make images which look as these do, relief engraving persists. Starve them of teaching, doom them to the depths of unfashionableness, people find their way back to it and reinvent it for themselves if necessary. It is now part of human language and is unique in the repertoire in that the drawing is done with light, the image coaxed from the original darkness of the block and the printer's ink.

When the odds are against, as they were for nearly thirty years until the early 1980s, a hundred fashions in painting may come and go while a few scattered engravers struggle on in isolation. Sheer survival does not make for good work. In periods of revival, larger questions of quality can arise. The answers are always the same. The quality of engraving depends on the quality of its practitioners as artists – artists in the full sense, who can confront their time in all its moral and linguistic complexity with a vision that is not secondhand. The re-emergence of wood engraving was a small result of that crumbling-away of modernist orthodoxies which affected everyone throughout the 1980s and ended in massive political and national change, as well as the discrediting of valid and nobly held ideals. The adoption of up-to-date modes and technologies was seen, for the first time in many years, as no guarantee of truth. The use of the oldest ones – painting, drawing and engraving, in the case of the visual arts – was therefore recognised as no bar to it. Those who felt drawn to this lovely but unfrequented medium no longer needed to feel shy, apologetic or defiant about their choice; but neither can they hide behind it. Wood engraving is a good tool to touch reality with – as good as any other – but the problem of touching reality in an alert and contemporary way remains.

Wood engraving has sustained its position in the commercial world, since the first edition of this book; the annual, touring exhibitions of the Society of Wood Engravers have grown in range and quality; the standard required for admission to membership has correspondingly risen; there are members and friends of the Society in Moscow and Montana,

Tasmania and the Isle of Skye; and the new work in this edition is stunning. The presence of art maintained by the best of current engraving is that of the impact on eye and mind of lived experience. In an art world rich in fantasy and fashion, that is not the only option for engraving or for art; but it is a perennial role, central to the history of the graphic arts: always changing, yet not changed merely by the currents of fashion. It is always needed – this second edition is only being published because of regular demand.

There is a blot on the horizon: there appears to be no British art school now which employs an artist on its staff to assert the positive presence of wood engraving in that place; whereas an etcher or screen print specialist will almost certainly be there. Wood engraving is at best passively available, on rare occasions. Most of those who come to it do so as mature students, or as sophisticated amateurs who lack the broad background of contemporary artistic awareness which professional education suppos-edly provides. Today's professional students, tomorrow's best artists, do not even get told that it exists, except by some fluke of personal contact.

In 1776 the Society of Arts made an award to Thomas Bewick to help him travel to London. In 1992 the Bewick Society, in association with the Royal Society of Arts, as it now is, and the S.W.E., has revived the award in the form of an annual sum of money for a young engraver under twenty-five. May it stimulate a generous response in future years; but how ironic that our art schools have become virtually incapable of producing a student to apply for it.

Real debate about art is not conducted in words, but in the images themselves. As in a game of cards, they rival or trump each other. It is the shock of seeing what another artist has *done* that stimulates response. Beyond being a handbook for business and connoisseurship, the aim of this new edition of *Engravers* is to widen the debate: to challenge established artists, to encourage newcomers and to engage a broader public.

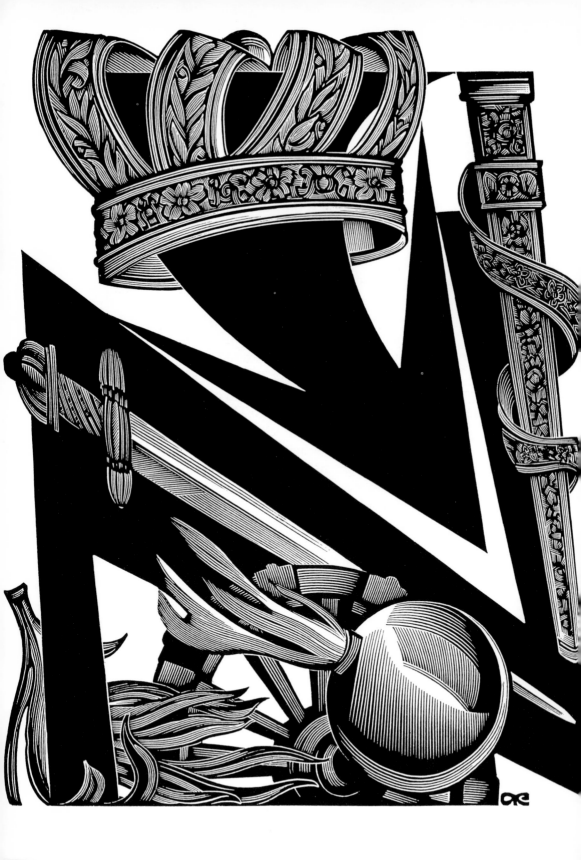

Anatolii Kalashnikov: from the *War and Peace* suite

PRELUDE

Anne Desmet and Peter Bosteels, there being just two engravers in the Society born in the 1960s, hardly constitute a generation, so are presented as a prelude to the four main, chronological sections of the book. Impressively, and not just as a result of undented youthful idealism, both appear committed to engraving primarily in a fine art context.

Peter Bosteels, largely self-taught, studied dusty nineteenth-century manuals and the works of Doré in the Academy of Fine Arts in Antwerp, and has reacted against this self-imposed classicism into a characteristically Flemish expressionism, a blackness and wild mockery which recall Ensor and Breughel. In 1988 he came to England with the promise of a scholarship for proper tuition in the birthplace of wood engraving. There wasn't any, as we have seen; so, like a sensible fellow, he took the money and went to Tenerife instead.

Anne Desmet, also basically self-taught, employs wood engraving to make prints and also, taking advantage of its power to multiply, as the raw material for delicate one-off constructions and collages in which space and colour play vital parts. Engraving is taken, literally, into another dimension. Time and mutation are themes in her print sequences too.

Whether this sense of engraving as a fine art statement is just coincidental or will be shared by others of this generation as they emerge to artistic maturity remains to be seen. Colin Kennedy's is work to watch in this regard (see page 130). What is so heartening is that the pendulum is still free to swing and that this work is just so different in aim and character from anything that has come before; the medium can still pull surprises and satisfy the artistic quests of very different sensibilities.

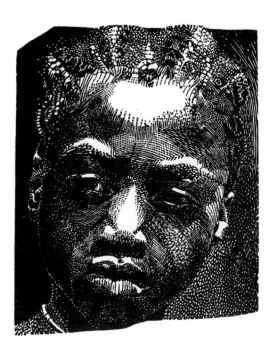
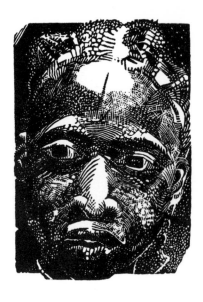

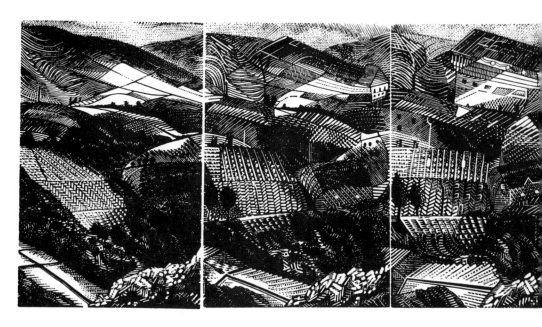

ANNE DESMET, b.1964, studied painting and printmaking at the Ruskin School, Oxford, where she was introduced to the idea of wood engraving. After a postgraduate diploma in printmaking at the Central, she spent a deeply influential year, 1989–90, as a Rome Scholar. She has taught engraving at the Royal Academy Schools, 1990–91, and done commissioned illustration (Oxford University Press; *The Times*) but is primarily a maker of independent prints and collages; she has had several solo exhibitions.

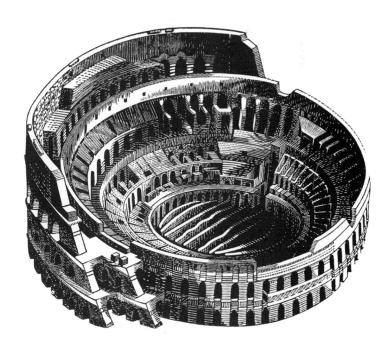

PETER BOSTEELS, b.1963, studied at Ghent and on a scholarship at the Academy of Fine Arts in Antwerp and the Antwerp National Higher Institute. He taught himself to engrave on blocks he made himself in the workshop of his father, a cabinet maker, and printed them with ink he mixed himself. On a student exchange and later a scholarship trip to Santa Cruz he found a home from his Flemish home in the experience of the carnival.

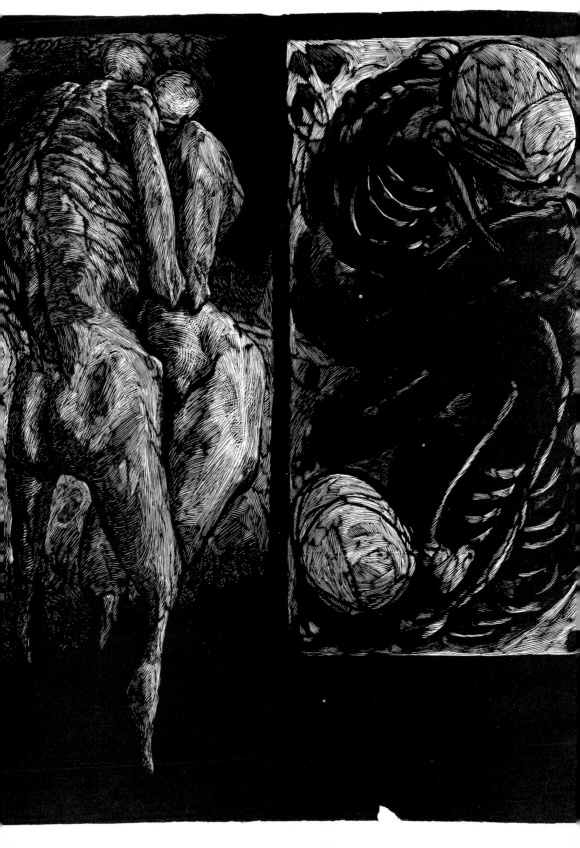

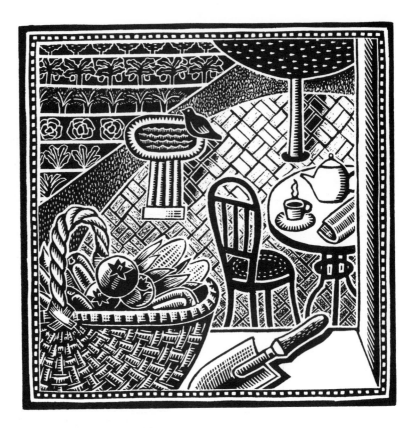

Beth Krommes
Chris Wormell

1

The renaissance of the 1980s was spearheaded into the public awareness by Andrew Davidson and Chris Wormell, two young illustrators who put wood engraving on to the packaging of major retail chains, into the columns of *The Times*, *The Observer* and *The Sunday Times* and into advertising campaigns, as well as into books. Credit for many of these initiatives should go to the design groups which employed them: Pentagram, for example, which also commissioned over 200 engravings from Kathleen Lindsley for use as signs on Samuel Webster pubs throughout Yorkshire.

These and other engravers in this section were born in the 1950s and so are in their thirties or early forties. The assurance of their work reflects the precocity forced upon students in recent years, by commerce, in the design field. Engraving is seen as part of graphics. Several who learned engraving (as opposed to being self-taught) learned it on graphic design courses.

Those who work as fine artists, outside the no less commercial gallery circuits, probably have other jobs and develop with less haste. Howard Phipps earned his living as a teacher for several years; Jeroen van Duyn supports himself with odd jobs while pursuing his vocation as a printmaker. Phipps has a painter's eye; his engravings reveal intensity of experience and a continually developing sensibility. The rich decisiveness of Harry Brockway's illustration evokes his other trade as a stonemason; remembering Gertrude Hermes, this seems a particularly profitable combination for an engraver. Beth Krommes brings the traditions of the Pennsylvania Deutsch both to timeless and to personal observations.

Almost all this work, including Phipps' and the dramatic, intelligent illustrations of Jane Lydbury, tends to respect the finesse and small size of wood engraving and to partake of a crisp, contemporary, graphic precision. Each mark must be good enough to take enlargement if necessary, and if this happens small size must not be seen to have equalled timidity or the lack of a sense of scale. Chris Wormell is prepared to look the Victorians in the eye and beat them at their own game.

 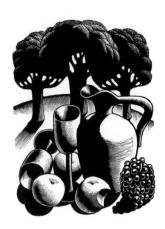

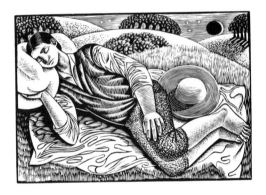

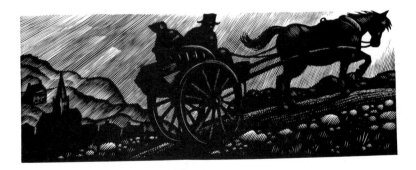

HARRY BROCKWAY, b.1958, studied sculpture at Kingston and at the Royal Academy Schools, where he learned engraving from Sarah van Niekerk. He makes his living as a stonemason as well as a wood engraver. The engravings shown here are from *The Lad Philisides*, a selection of songs by Sir Philip Sidney (Old Stile Press 1987), the Reader's Digest Bible, for which he produced over fifty wood engravings, and *Agnes Grey* (Folio Society 1991).

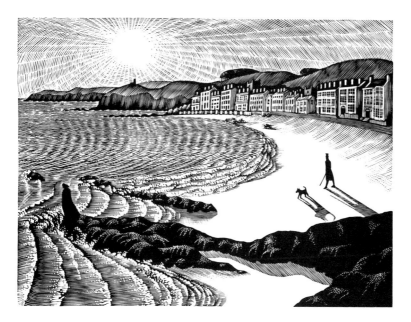

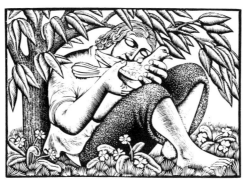

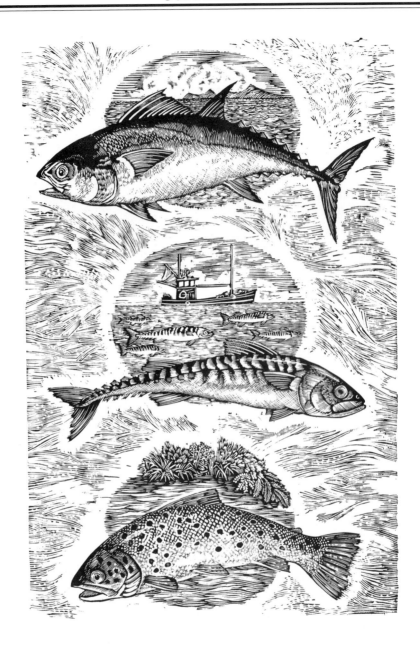

SUE SCULLARD, b.1958, was taught to engrave by Yvonne Skargon at the Royal College. She works as a freelance illustrator in various media, using water-colour particularly for topographical or children's books, and engraving for commissioned book illustrations, packaging and advertising work. She has illustrated *The Bride of Lammermuir* for the Folio Society and has contributed to their *Canterbury Tales*. She enjoys engraving decorative subjects and landscape, particularly mountainous scenes, and works on linoleum and vinyl when deadlines are urgent or bolder effects are required.

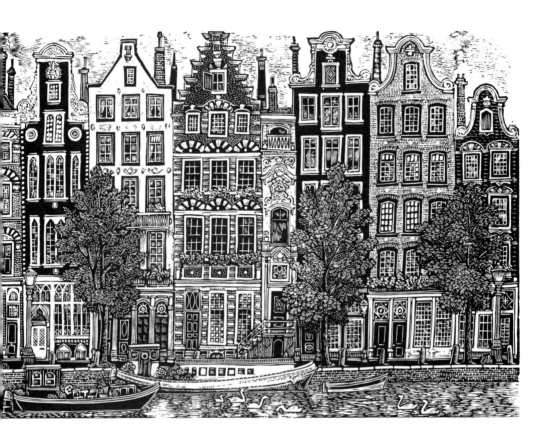

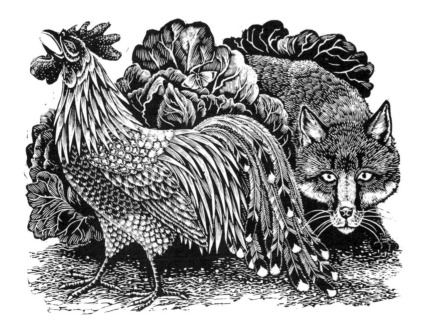

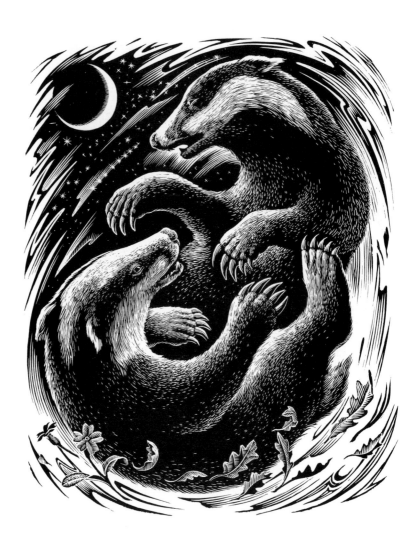

ANDREW DAVIDSON, b.1958, was introduced to wood engraving by Fred Dubery, Yvonne Skargon and John Lawrence at the Royal College of Art. His designs range from postage stamps to the murals at Gatwick Airport, and he has used engravings for Crabtree and Evelyn packaging and *Times* editorial pages, and in illustrations for *The Iron Man* (frontispiece) and *Tales of the Early World* (opposite) by Ted Hughes, and Gene Kemp's *The Mink Wars* (above), all published by Faber and Faber.

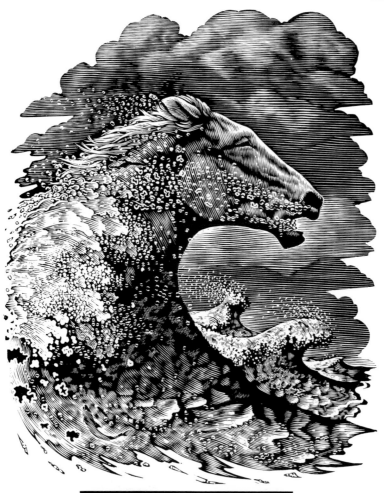

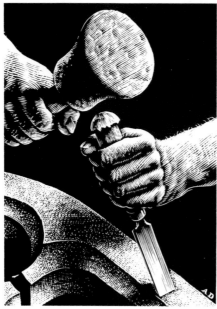

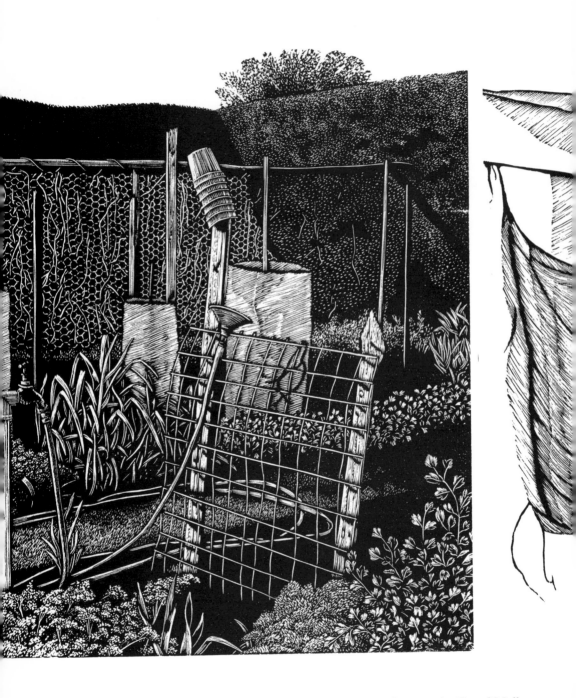

ROSALIND ATKINS, b.1957, was a student of Tate Adams at the Royal Melbourne Institute of Technology. She works in Melbourne mainly as a wood engraver and book illustrator. The engraving above is from her own book, *Recollections*, while the print *Prayer Flags* employs a technique of blind embossing and delicate relief printing from the same block.

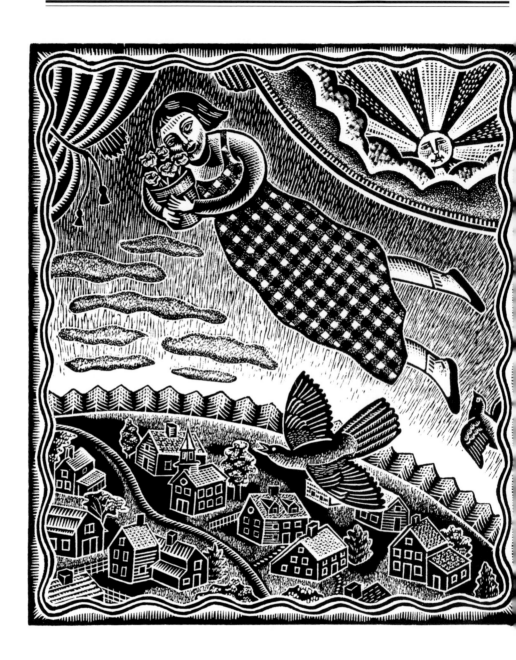

BETH KROMMES, b.1956, became interested in wood engraving on seeing work by Herbert Waters, Randy Miller and Nora Unwin, at Sharon, New Hampshire. She has degrees from Syracuse University and the University of Massachusetts, and spent a year at St. Martin's School of Art in London. She has been illustrating full-time since 1989, with commissions from book, magazine and newspaper publishers including HarperCollins, Wm. Morrow, Bantam/Doubleday/Dell, *Time magazine, Country Living, The Boston Globe* and *The New York Times.*

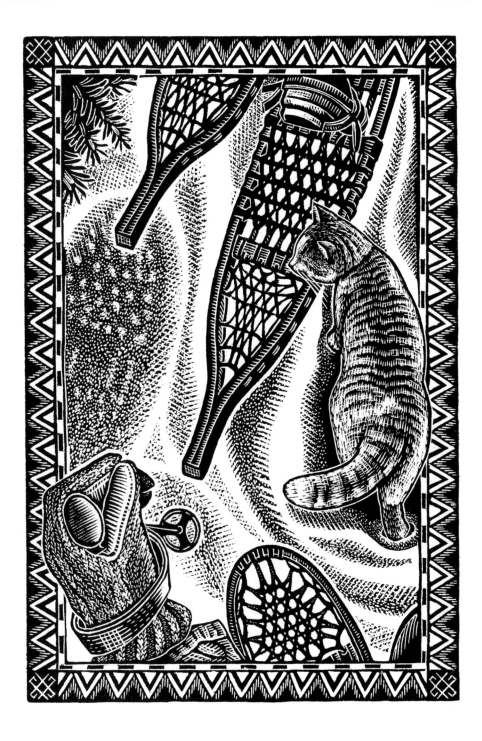

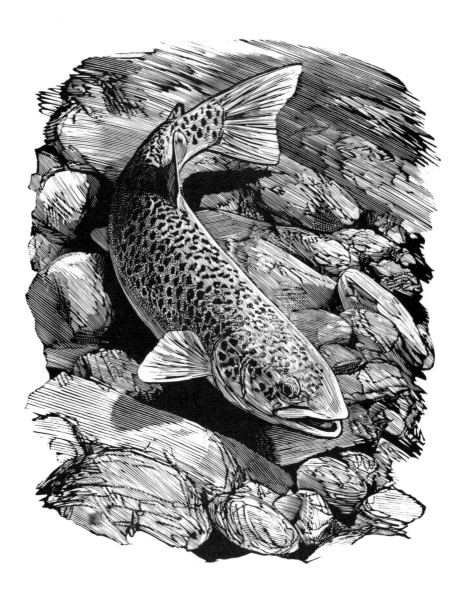

CHRISTOPHER WORMELL, b.1955 in Gainsborough, Lincolnshire, was self-taught as an engraver and has worked as a freelance illustrator since 1983, mainly as a commercial artist. His *English Country Traditions* was first published in limited edition by the Victoria and Albert Museum and then in a trade edition by Pavilion Books (1990). He has worked for numerous publishers and agencies, and his illustration includes *The Jungle Book*, the writings of John Clare, and more than one book about fishing.

HOWARD PHIPPS, b.1954, studied painting and printmaking at the Gloucestershire College of Art 1971–5, followed by a further year at Brighton. His engravings are mainly done as free prints, but they have also appeared in a number of books, notably his own purely visual *Interiors*. A colour print from this now rather celebrated volume won the Christie's Contemporary Print Award at the 1985 Royal Academy Summer Exhibition. *Further Interiors* was published, also by the Whittington Press, in 1992.

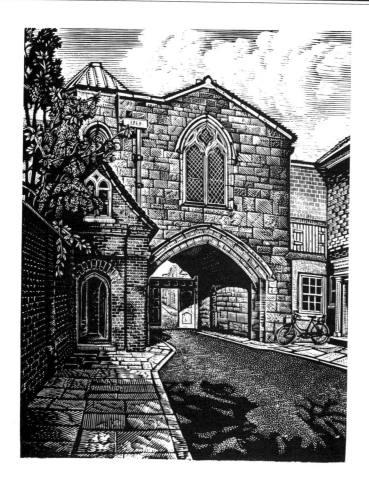

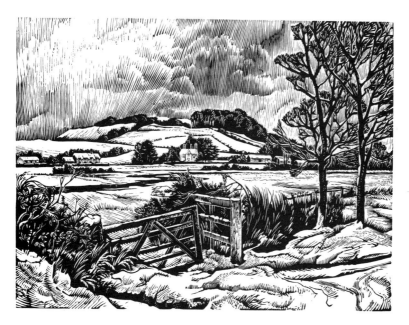

JANE LYDBURY, b.1953, studied English at Cambridge and taught for some years before turning to art and graphic design. She graduated in 1981 from Camberwell, where she had studied wood engraving under John Lawrence. The engravings shown here are from *This Solid Globe*, a book about Shakespeare's theatre (Camberwell Press 1984). Recent work includes a distinguished edition of Emily Dickinson's poems and *The Norse Myths* for The Folio Society.

J ONATHAN G IBBS, b.1953, is a painter whose use of engraving was first suggested by literally cutting or carving into the surface of chalk drawings done on heavy-duty paper. He has a strong interest in sculpture and craft processes; engraving satisfies those concerns and provides an outlet for graphic themes in contrast to the predominantly abstract character of his paintings. Some of his engravings appear as prints, others have given their very individual stamp to a number of books.

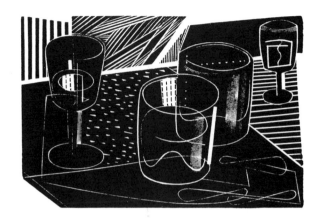

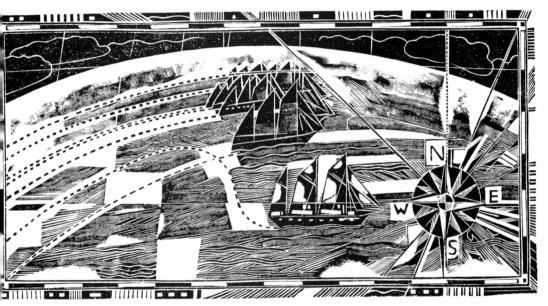

KATHLEEN LINDSLEY, b.1951, educated in Australia, Singapore and England, graduated in fine art from Newcastle, where Leo Wyatt first introduced her to engraving. She has been self-taught thereafter and now lives on the Isle of Skye, where she founded the Struan Craft Workshop in 1979. She works primarily as a wood engraver and illustrator and has had several one-man exhibitions. She describes the Pentagram Samuel Webster commission as providing a great boost to technique – as well as making her work more widely known.

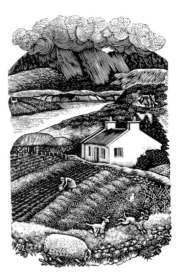

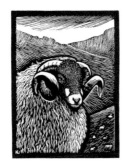

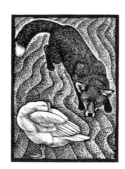

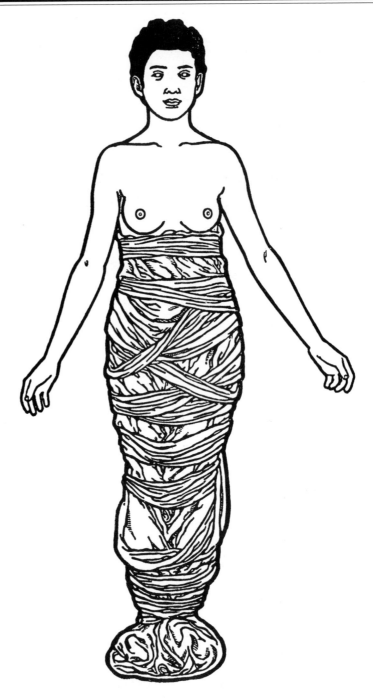

JEROEN VAN DUYN, b.1952, currently resident in France, is self-taught as a multi-block colour-printmater. He works both through fine engraving and the effect of one printed colour on another, sometimes through a great many subtly differentiated printings. Only simple examples will bear reproduction here and on the back cover. The image above was printed on a greenish paper in black, umber and (for the winding sheet) white, in *Tien Verzen voor een Doode* (Ten verses for a dead woman): Avalon Press 1991.

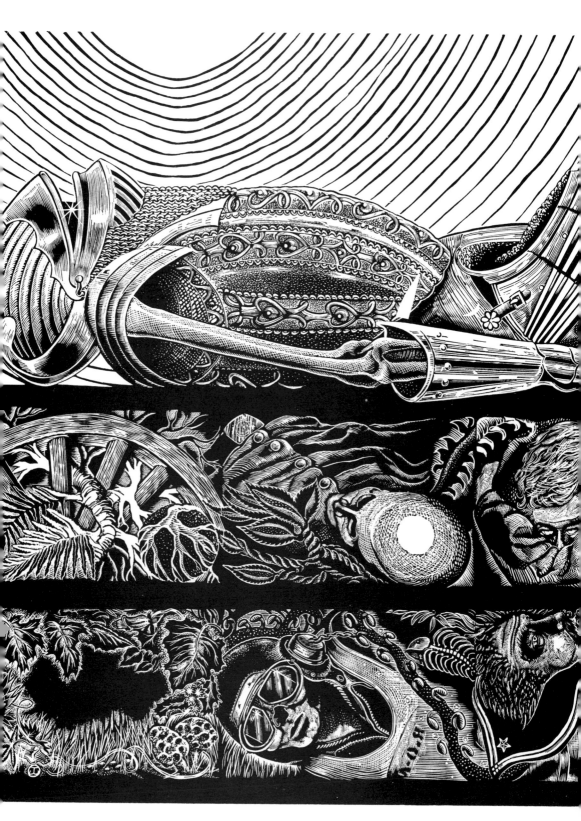

Judith Jaidinger: *A matter of Time* (detail). See p.68

Simon Brett
Claire Dalby

2

Compared to the crisply graphic white-line in section one, those of us in our forties and early fifties present a diversity of approaches, from cool, tonal composition to robustly physical cutting. In Judith Jaidinger's case, skills learned in the last of the trade engraving workshops are now harnessed to the ends of an artist-printmaker's highly individual vision. Ray Hedger emphasises the hard, flat printing surface as a mesh of black-line facsimile, with textural infill. Claire Dalby lowers that printing surface itself, as Bewick did, to achieve exquisite atmospheric greys. Like those of Paul Kershaw they are astonishing and almost impossible to reproduce. Contrasts no less surprising could be drawn between Anne Jope's meditations, Colin Paynton's mesmeric patterns, which spread across the page like slow explosions, and Ian Stephens' engravings, in the sheer truth of which the line from Bewick is at its most authentic.

Equally diverse are the ways my contemporaries go about things, their ambitions, the sort of artists they are trying to be.

Ours was the last generation in which engraving was taught as part of an artist's general education. From the late 1960s, art education in Britain was completely overhauled and tuition in engraving disappeared for some years. It was resumed under the wing of graphic design – as education with a direct commercial application. The gap is very visible.

The former variety and availability of teaching, the sense of isolation occasioned by the break, the concentration of engraving in the graphics departments of fewer schools – with all the shifts of attitude involved therein – may largely explain the noticeable difference between generations: diversity in this one, concentration on technical finesse in the next (the previous section). But also, whatever work we have done before, in our forties we begin to understand where we want to go; we distinguish the influence of teachers and the limitations of fashion and demand, from our own purposes. As I try to reconcile visual experience in its painterly tone with emotionally experienced ideas and destinies, that, at least, is how it seems to me. Such emerging certainty enabled Edwina Ellis and Peter Smith, coming to engraving from other fields, to charge it with technical inventiveness and thematic originality.

PAUL KERSHAW, b.1949 in York, trained for the teaching profession in Newcastle and spent twelve years as an art teacher before leaving to concentrate on his own printmaking in 1984. He began wood engraving, self-taught, in 1985. So far, most of his work is a personal response to the landscape of north-west Scotland, especially the Isle of Skye, his home since 1986. He publishes his prints, black and white and colour ones, in limited editions, printed by himself and usually sold through galleries and exhibitions.

Edwina Ellis, b.1946, was originally a jeweller in Sydney, Australia. Wood engraving evolved from metal engraving with the help of two summer schools with Simon Brett. Colour engraving developed after a visit to Morocco in 1984 and experiment with commercial three-colour separations (see back cover). A Southern Arts touring exhibition featured her work in 1991 and she exhibits in London with Duncan Campbell Fine Art, publishing her work in individual limited editions and, on occasion, in boxed sets.

PETER SMITH, b.1946, a painter and printmaker, has been Head of Art and Design at Kingston College of Further Education since 1983. From 1977 to 1979 he was West Midlands Fine Art Fellow and has recently taken a postgraduate diploma at Wimbledon. He has exhibited in the Midlands, London and overseas and brings to engraving, from his painting, a vision as personal and rooted in experience as it is characteristically low-key.

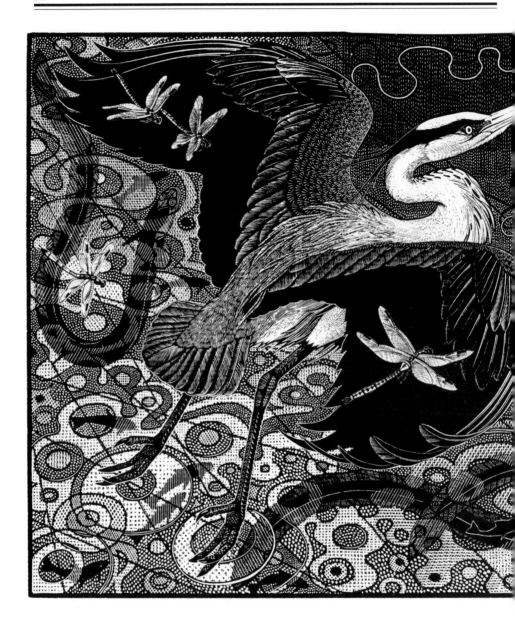

COLIN PAYNTON, b.1946, lives in Wales and is a watercolour painter and printmaker, self-taught as a wood engraver. He has illustrated several books, notably for the Gregynog Press in Wales, but also for the Gruffyground and Barbarian Presses. A fellow of the Royal Society of Painter-Etchers and Engravers, he also belongs to various associations of wildlife artists: this is an area both traditional and traditionally limiting for wood engravers and it is exciting to see its conventions so thrilling transcended.

ANNE JOPE, b.1945, studied painting at the Central School and did a post-graduate printmaking diploma there; she learned wood engraving from Blair Hughes-Stanton and Ian Mortimer. Turning to painting and thence print-making late, as a mature student, she has exhibited widely in Britain and abroad and describes herself as 'just someone now trying to print in a painterly way, in an effort to understand the inner and outer worlds.'

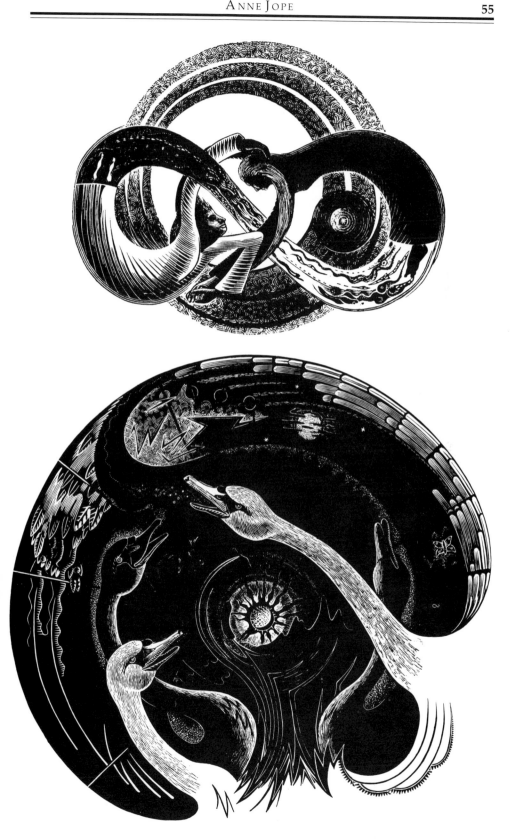

RAY HEDGER, b.1944. Introduced to engraving by Kenneth Lindley at Swindon School of Art, Ray Hedger's interest was developed by Hermes, Hughes-Stanton and Barrett at the Central School. Later he became interested in film-making as an extension of painting, and was self-taught in this, though in contact with Norman McLaren. His film based on Ted Hughes' *Crow* has been shown in a number of festivals around the world. He worked in arts administration for Thamesdown and R.A.F. Fairford from 1983. In 1988 he returned to full-time painting and engraving.

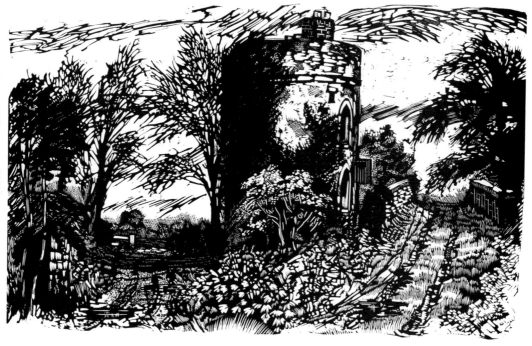

The engravings on this page are reduced by 69%.
The detail opposite is reproduced full size.

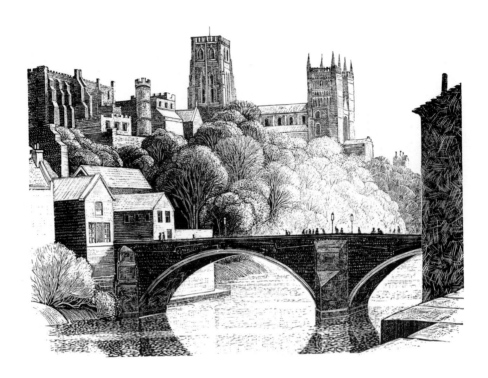

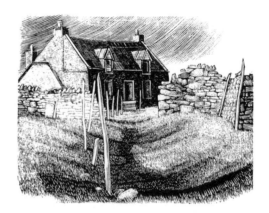

CLAIRE DALBY, b.1944, learned the rudiments of engraving at the City and Guilds School but never saw anyone else engrave wood until quite recently. Specialised also in lettering, she has worked since 1967 as a wood engraver, watercolour painter and botanical illustrator. She exhibits regularly and is a Vice-President of the Royal Watercolour Society. Published botanical work includes *The Observer's Book of Lichens* and Natural History Museum wallcharts. Her wood engravings are mostly limited edition prints; commissions include a frontispiece to *Even the Flowers* (Gruffyground Press) and some bookplates.

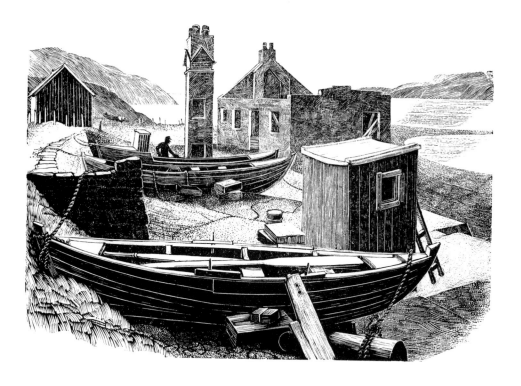

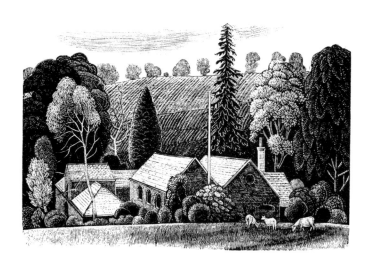

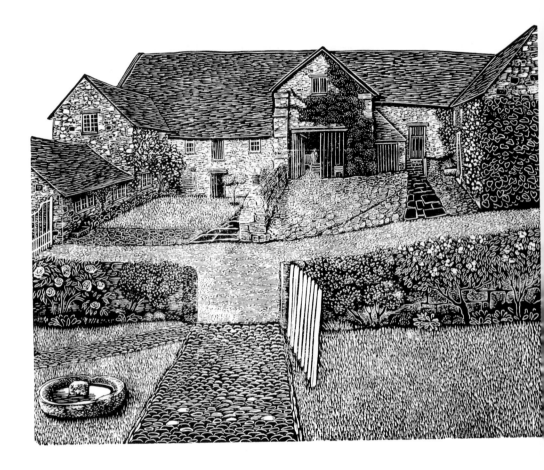

HILARY PAYNTER, b.1943, has enjoyed parallel but quite separate careers in education and in engraving for twenty years. She was taught engraving at Portsmouth by Gerry Tucker and also studied sculpture. She has more recently completed an MA in education and an MSc in educational psychology. She has been deeply involved in the renaissance and organisation of the Society of Wood Engravers, of which she is the indefatigable and unpaid secretary. She is intrigued, according to mood, by a wide range of subjects – social issues, weathered stones, the state of man – and is prepared to explore these topics in her engravings. In 1991–2 a major exhibition of her work was seen at Hereford Museum and in Oxford.

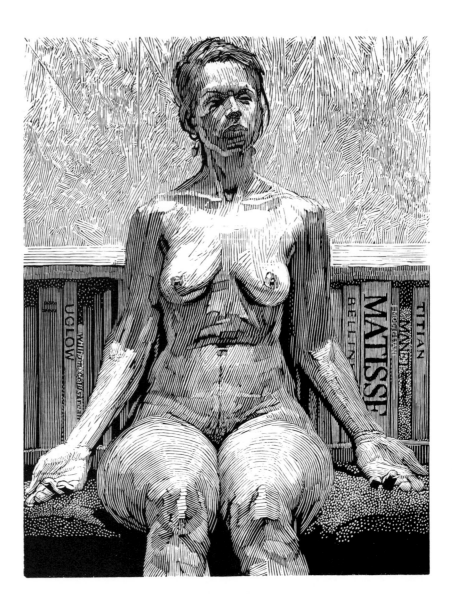

SIMON BRETT, b.1943, learned engraving from Clifford Webb at St. Martin's School of Art, lived as a painter in New Mexico and Provence and taught for 18 years in the art school at Marlborough College in Wiltshire. In 1981 his first book illustrations won a Francis Williams Award and recent advertising work also won awards for the commissioning agency. Two monographs have been published on his bookplates. Now freelance, he has illustrated the New Testament for Reader's Digest and *Clarissa* and *Jane Eyre* for The Folio Society. He is the current chairman of the Society of Wood Engravers and the compiler of this book.

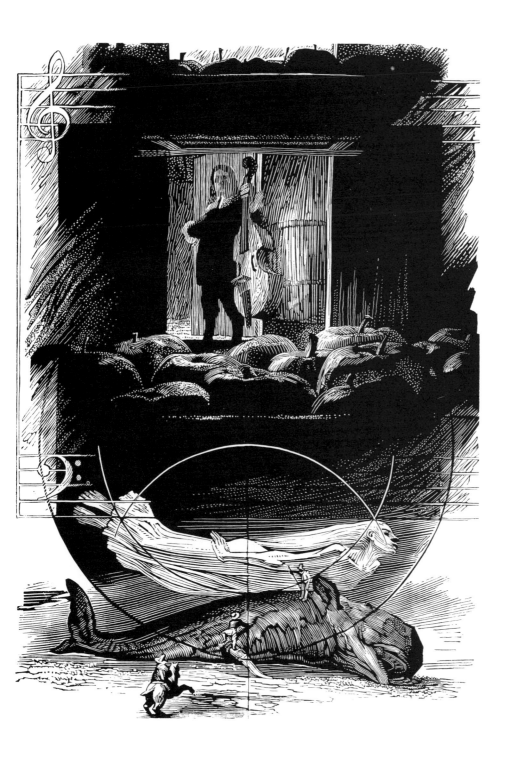

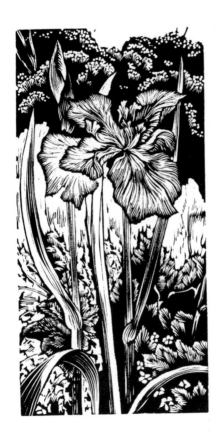

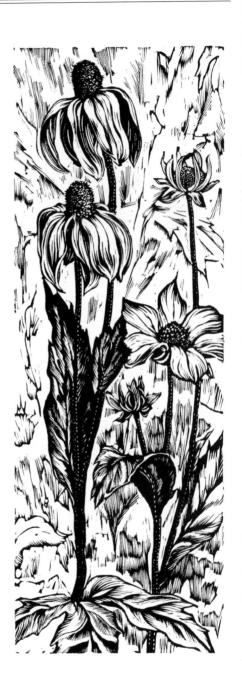

GERARD BRENDER À BRANDIS, b.1942, calls himself a 'bookwright': as engraver, printer, binder and on occasion papermaker he has produced handmade, limited edition books since 1969, 'along with a raft of single-leaf prints for framing and lots of ephemera'. Mostly self-taught, with some help from Rosemary Kilbourn, he fell in love with the clarity, decisiveness and movement from dark to light of engraving, and with the wood. These prints are from a book of forty views of the Royal Botanical Gardens, Hamilton, Ontario. He is also a gardener.

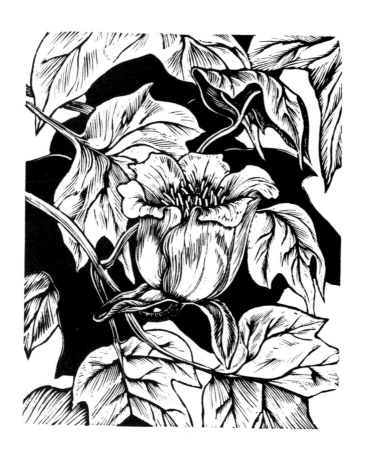

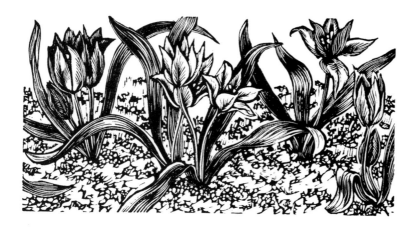

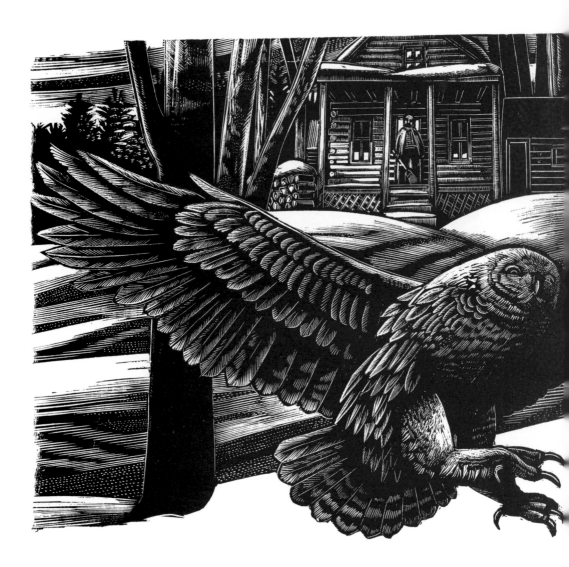

MICHAEL McCURDY, b.1942, began engraving in 1962 while an art student in Boston. Early influences were Lynd Ward and Fritz Eichenberg, men with whom he had occasion to collaborate in later years. He has been a small-press publisher of contemporary literature (Penmaen Press), a teacher, and a freelance book illustrator and author. All his engravings have been commissioned by publishers or corporate clients. His work is represented in several galleries. Recent work includes engravings for a letterpress edition of David Mamet's play *American Buffalo*, for the Arion Press, San Francisco.

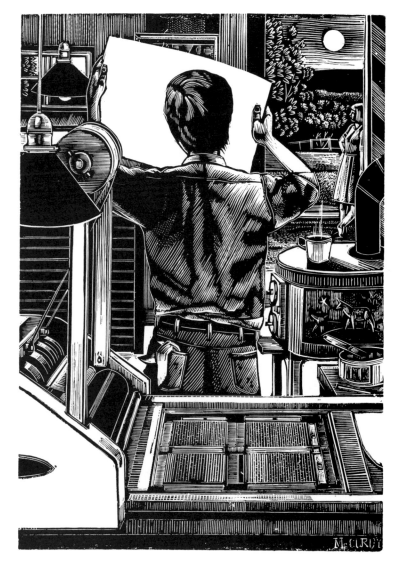

next page

JUDITH JAIDINGER, b.1941, studied at the Art Institute of Chicago 1970, but also worked in the Sander and the Zacher Wood Engraving Companies as a trade engraver, in the same city. She has exhibited regularly and extensively since 1963 and her prints are in the collections of a number of American States and institutions. She is not an illustrator. Though a lover of tradition, she does not allow tradition to determine how she sees or interprets life through her art.

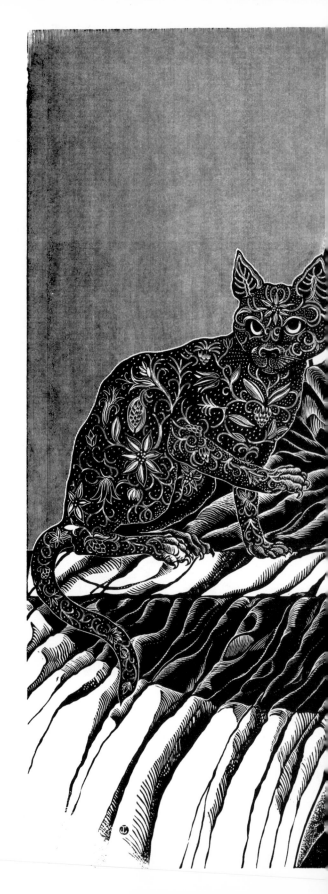

Judith Jaidinger
See text on previous page

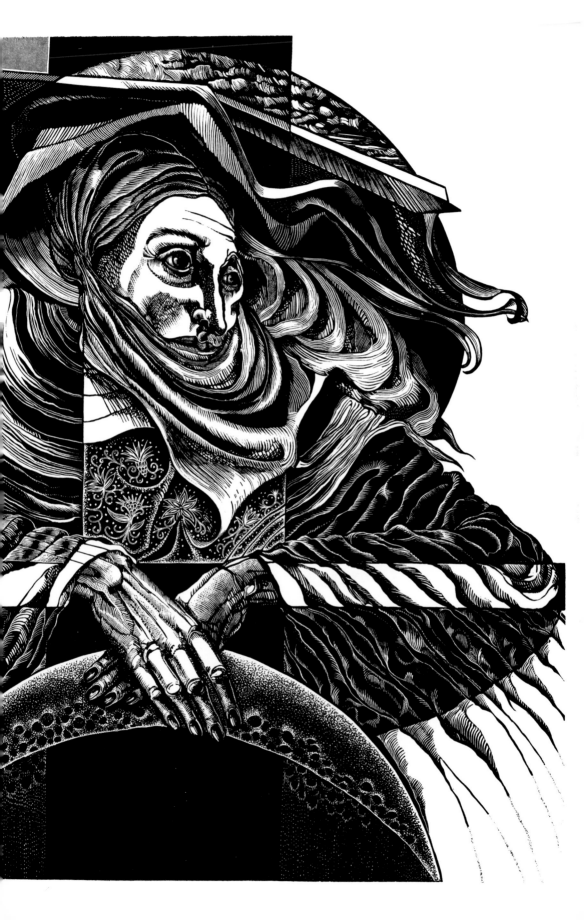

IAN STEPHENS, b.1940, trained in illustration at Northampton and took up wood engraving on leaving art school. After a long period of fitting his engraving into spare time away from teaching and then from managing a design studio for a large mail order publisher, he is now working freelance on commissioned illustration and graphic design, including the engravings for Parson Woodforde's Diary and *The Tenant of Wildfell Hall* from their Brontë series, for The Folio Society, shown here.

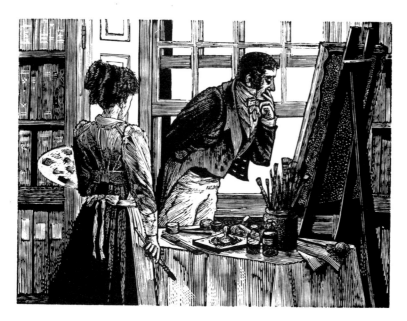

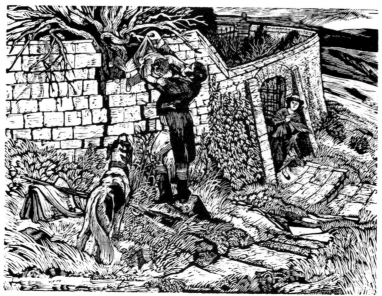

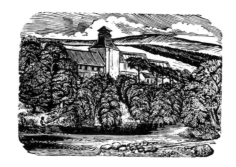

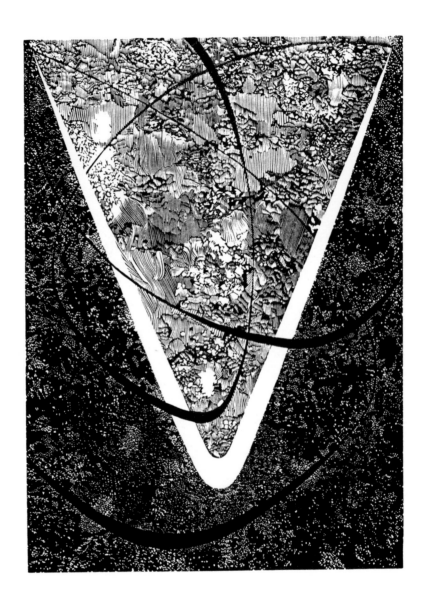

GRAHAM WILLIAMS, b.1940, private press printer (The Florin Press) specialises in the printing of wood engravings, but his appreciation of the book illustration of other artists has not led his own work in that direction. Light, space and movement are his artistic preoccupations, expressed in sculpture; and in wood engraving in the illusion of three dimensions through the letting-in of light.

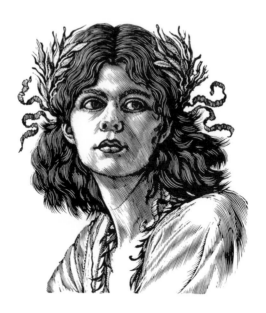

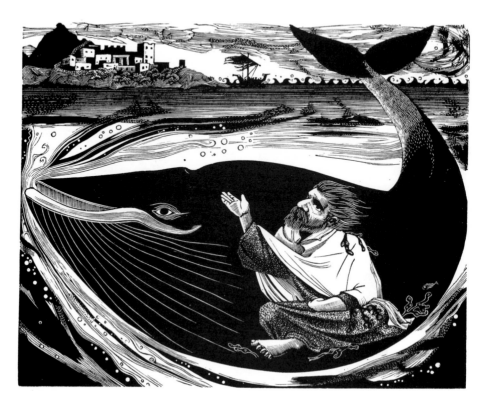

Richard Shirley Smith
Sarah van Niekerk

3

Since none was born later than 1939, the artists in this third section are all in their fifties or even approaching sixty, and turning fifty with a body of work behind you deserves a celebration. Even Hilary Paynter (p. 60), who has not yet reached that age, had a big retrospective exhibition in Hereford and Oxford in 1991–2, while over the winter of 1985–6 both George Tute and Richard Shirley Smith had major retrospective shows, at the Bristol Museum and the Ashmolean Museum, Oxford, respectively. In 1986, a magnificent volume of *Selected Wood Engravings* by John Lawrence was published by the Camberwell Press. Peter Forster celebrated by taking early retirement from English Heritage, to make sure there would be a body of work before him too. For even if life has allowed you to get enough done for a retrospective exhibition, reflection upon the distance travelled at fifty is a girding of the loins for even more fruitful voyaging to come. We trust. Some, like Richard Shirley Smith and Garrick Palmer, have moved off into other areas of work, but their engravings are retained in this edition because of the striking contribution they have made.

All these engravers have found themselves as artists and have established a level of creativity and a modus vivendi. They were old enough to survive the 'break' by being already launched into work and working contacts. If teaching, they had, before too long, acquired enough influence to ensure that engraving was resumed in schools eventually and for a time; the young men and women in section one have been their students; educational cuts and changes of attitude have now put paid to that, though.

If there is a leitmotif to their work, it is the opposite of the controlled white-line of the younger artists. Many of these engravers are characterised by the free, black-line facsimile cutting, already seen in the work of Ray Hedger (p. 56). There, it derived from the late Kenneth Lindley; in Pat Jaffé's work, homage is paid to Leonard Baskin.

Black-line facsimile cutting means the translation of apparently overlaid drawn pen lines into the smooth, unlayered surface of the block, by

cutting *between* the strokes of the drawing, or outside them. It touches the paradox and fascination of relief printing: that where, in painting or drawing, you read a series of marks, made over a period of time, beside or on top of each other, on a field which is usually the whole page: in a print, a complicated design, apparently of many lines but in fact a single smooth surface, is stamped at one go on to the page – and you usually read within the stamped area alone. The graver draws in white, which is positive; and the wood prints from the black beside where the graver cut: that's positive too. Cut and print are both direct marks, and they are not the same. In the history of modern art, which is the rescue of gesture from illusion, this is a uniquely clear state of affairs.

The second motif of this generation is the consciously rich variation of textural marks which pattern 'between' the 'drawn' lines but actually bring them into being.

Together, these motifs constitute one of the most liberating approaches of the century. They give the work of artists of the post-war period an entirely different character to those of the well-documented generations which flourished between the wars; though it is seldom acknowledged as such in the literature. Differently expressed, the sparkling cutting of these artists involves the rediscovery and enlargement of nineteenth-century reproductive engraving; but where that was microscopic and based in painterly tone, this is vigorously large and exposed in graphic marks. The merely reproductive becomes creative.

Clearly, this analysis applies to the work of more artists than the handful here represented, as well as to others in other generations; and there are artists such as Richard Shirley Smith who share the textural language but make very different use of it, the pecked, coruscating cutting referring to the worn and enduring surfaces of things and the play of light upon them as much as to the surface of the page or block. The analysis does not apply very much to the two Americans, Westergard and Todd, who have come to similar authority by another route. The common factor is that it is the content and atmosphere of the artist's vision which, first and last, you notice and remember, because that is what artistic maturity gives.

CORDELIA JONES, b.1936, discovered engraving through contact with Patricia Jaffé at Cambridge. As a writer of books for older children, it appealed to her as the perfect complement to type; ?the first book she illustrated was her own *A Cat Called Camouflage* (1970). Dissatisfied with the printing of the engravings, she bought a press in 1977 and began to produce cards, letterheads and other epherera. In 1984 she exhibited in *The Artist at Work*, at Norwich, and in 1986 illustrated two books for the Japanese publishers, Iwanami Shoten.

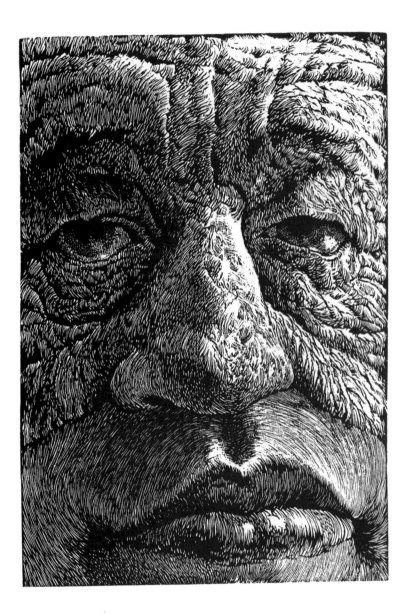

JIM WESTERGARD, b.1939 in Utah, is now a Canadian citizen and has taught drawing and printmaking in Alberta since 1975. His printmaking in several media combines a deadpan and poetic sympathy with an equally deadpan humour. The print on p.12 of *The Lone Ranger (Ret.)* relates to a sequence about whatever happened to Canadian comic book heroes (whom no one had ever heard of anyway). Like a number of Westergard's engravings, done with burins and with small-scale power tools, the prints are delicately hand-coloured.

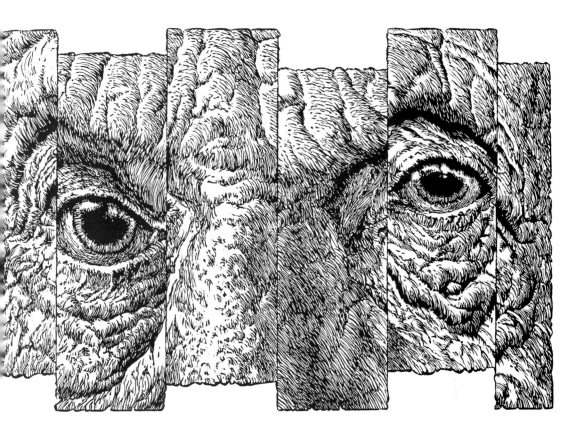

ACTIVE JIM

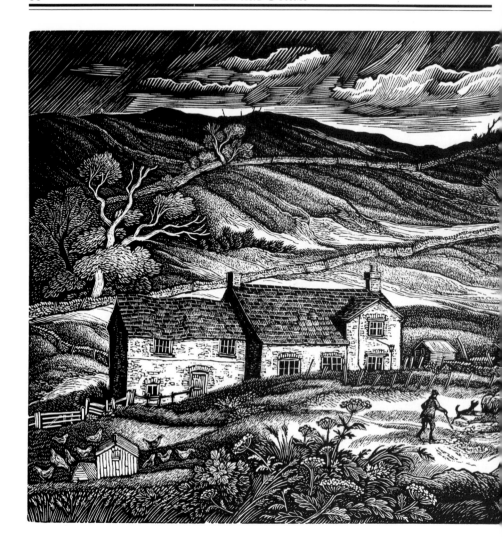

EDWARD STAMP, b.1939. Wartime evacuation from London's East End to a Buckinghamshire hamlet illuminated Edward Stamp's future life. He studied illustration at Northampton and, while working with Her Majesty's Stationery Office, discovered wood engraving in Holborn Library. Quitting urban life, he took work as a tractor driver and combined art and agriculture until the early 1970s when it became possible to paint full time and live by it. Primarily a painter, he has done a lot of engraving. He finds it a unique means of transforming an idea into an image that commands attention.

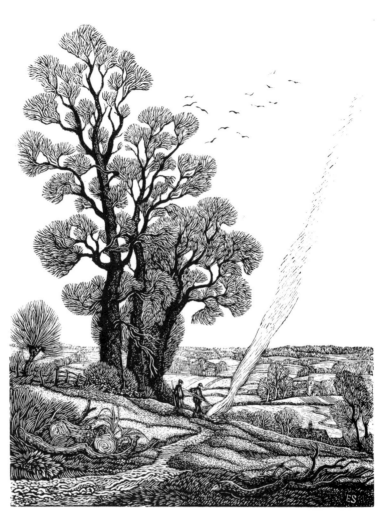

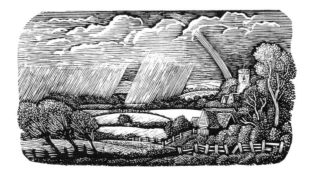

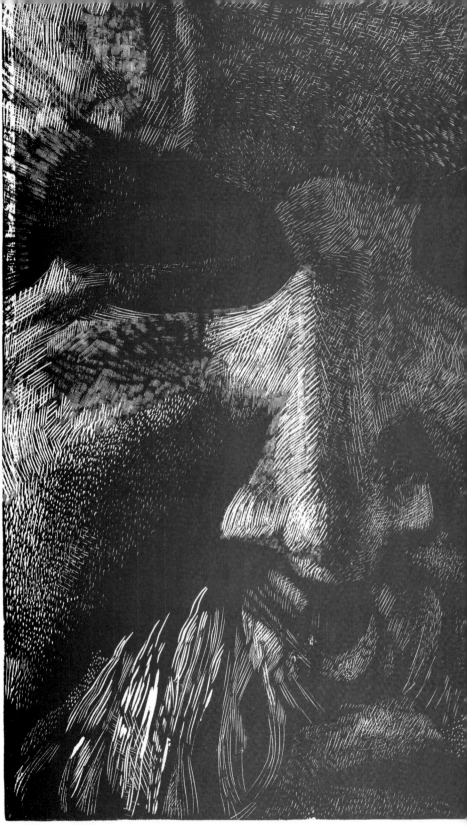

JAMES TODD, b.1937 in Minneapolis, was raised in Montana and is now Professor of Art and Humanities at the University there, specialising in the social theory and history of art as well as in painting and printmaking. His work frequently has social and political themes, has ranged from the fantastic to the naturalistic and has been especially influenced by German and Mexican political art; but formal

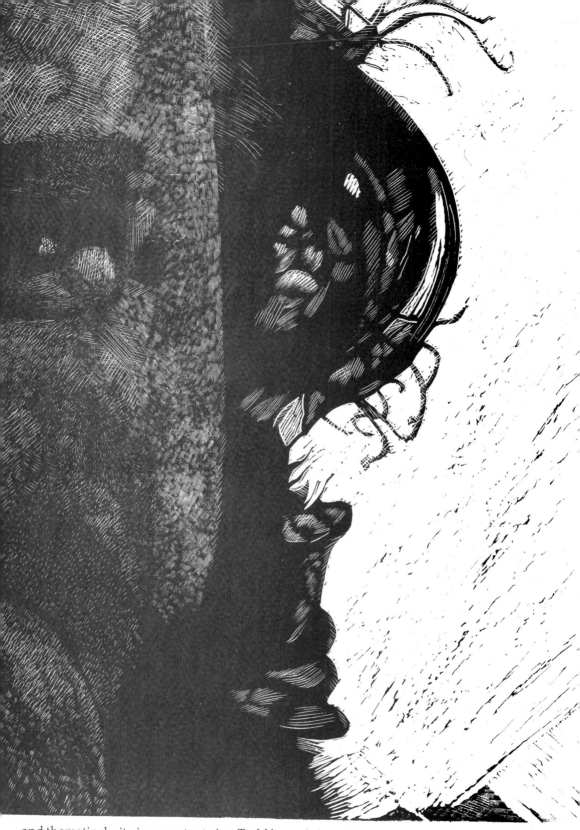

and thematic clarity is a constant aim. Todd has exhibited throughout the U.S.A., in both Germanies, Spain, Bulgaria, South America and China, with which he organised the first ever university exchange of students and teachers of art. This print is reduced to 75%.

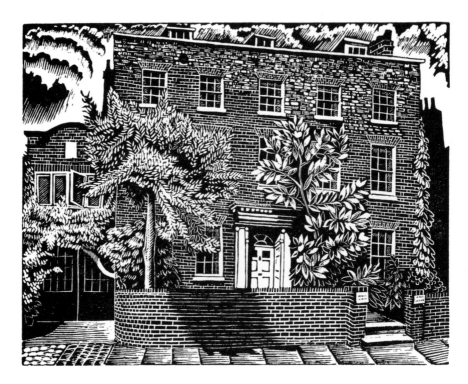

ROSALIND BLISS, b.1937 in London, was educated in Scotland and took her diploma at Edinburgh College of Art in mural painting. She lives in London as a part-time teacher, painter and engraver, which latter she took up in 1971. She does bookplates, letterheadings and Christmas cards on commission.

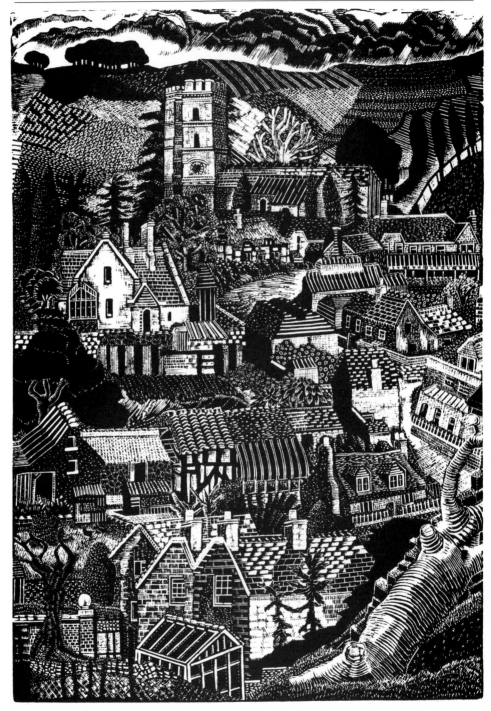

Yvonne Elston, b.1935, is an artist in black-and-white media, drawings and prints, who has exhibited widely over the years, particularly in international print exhibitions in Europe. Drawing is her main field. In engraving, to which she was originally introduced by Gerry Tucker, her preoccupation is with textural and tonal variations and the 'colour' that may be achieved by the balance of blacks and whites and greys.

PATRICIA JAFFÉ, b.1935, trained as an academic and has constantly looked upon painting and printmaking as an escape. She remains an amateur wood engraver in her own estimation, but is still looking for time to do more. Her subjects tend to be single, isolated and small, or else pay homage to draughtsmen who lived too early to be able to design for wood engravers. Patricia Jaffé learned to engrave from books and then learned to make wood-cuts from Leonard Baskin, for whom she subsequently worked as studio assistant 1959–62. She exhibits under the name of Milne Henderson.

MIRIAM MACGREGOR, b.1935, worked for the publishers B. T. Batsford for several years in their Art Department and subsequently freelance. In 1977 she joined the Whittington Press, where she still works as a part-time compositor, and for whom she has illustrated a distinguished and delightful sequence of books, as well as others, for other fine presses or publishers for whom Whittington prints. No one taught her to engrave: Stanley Lawrence gave her a demonstration over the counter, she says.

RICHARD SHIRLEY SMITH, b.1935, first achieved prominence as a wood engraver – he illustrated over thirty books, among them *The Poems of Percy Bysshe Shelley* for the Limited Editions Club, *Messer Pietro Mio* (Libanus Press) and others for The Folio Society – but he now works as a painter and maker of mural decorations. Some of his finest independent works have been done in collage, his use of which is as individual and perfectionist as his engraving. He has also engraved many bookplates and ephemera. He was entirely self-taught as an engraver.

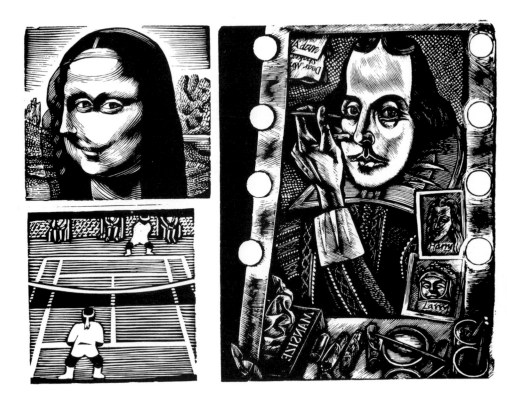

PETER FORSTER, b.1934: commercial artist, second generation wood engraver, son of the late Mendip Dewhurst. Commissioned by Saatchi and Saatchi, *The Times*, *Observer*, National Trust and Folio Society (Chaucer, Shakespeare, *Wuthering Heights*, his own edition of *De Profundis* and − see front cover − *The Rape of the Lock*). Author of The Malaprop Satires: The Whitehall Venus, An A − Z of English Culture, etc. Supplier of red herrings to the Society of Wood Engravers.

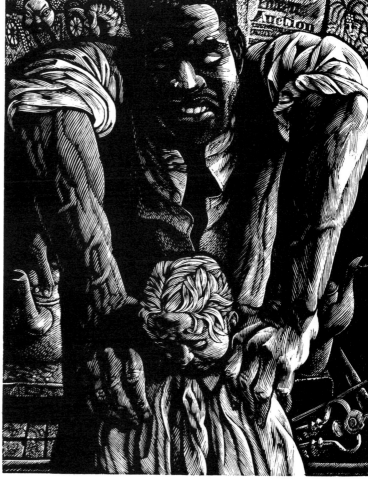

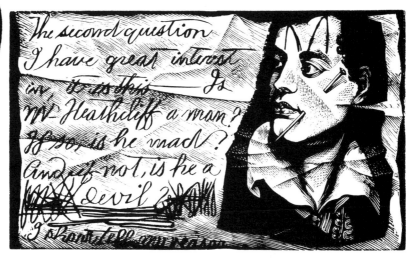

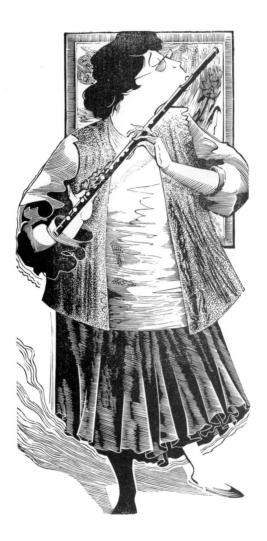

SARAH VAN NIEKERK, b.1934, learned engraving from Gertrude Hermes at the
Central School and was later herself tutor in wood engraving at the Royal
Academy Schools from 1976–86. She is a Fellow of the Royal Society of Painter-
Etchers and Engravers, The Printmakers Council and The Art Workers Guild and
has exhibited regularly and all over the world. Though Sarah van Niekerk has
illustrated several books, for example for the Folio Society and the Gregynog
Press, she is primarily a maker of independent prints – wood engravings and
large colour wood and lino cuts.

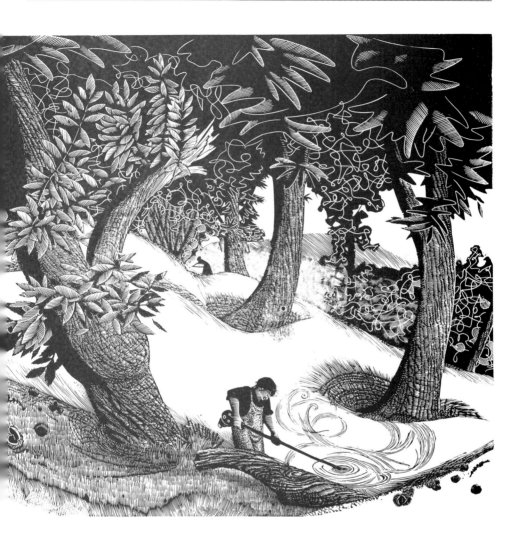

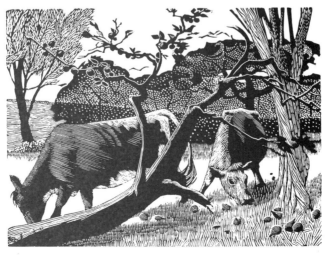

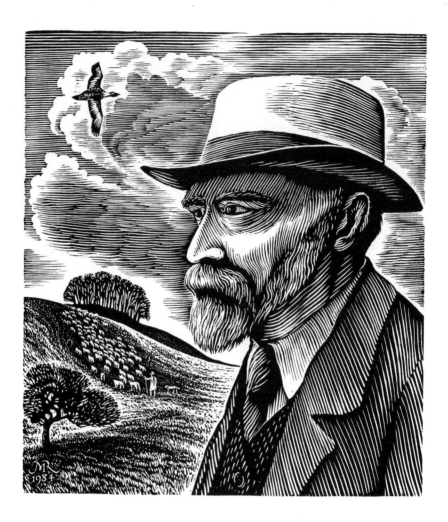

MICHAEL RENTON, b.1934, found himself in the 1950s formally apprenticed to what was left of the wood engraving trade. He also studied, erratically, at Harrow and City and Guilds art schools. He has since diversified into other media, notably the lettering crafts and, lately, has found his engagement with the wood block deepened by an examination of its history. For half his life he has worked near Rye in Sussex, for the most part entirely freelance. His output includes some independent prints, along with illustrations, bookplates and miscellaneous commissions, including a deal of lettering in stone, slate and other materials.

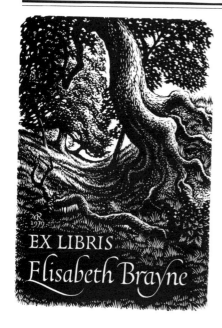

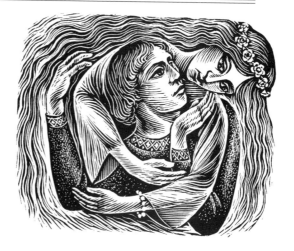

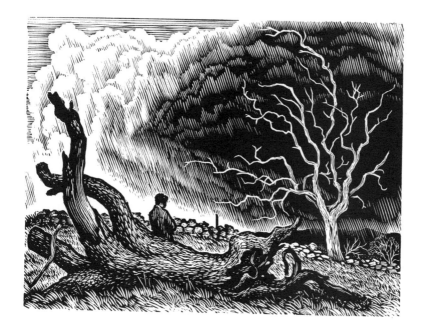

M. J. MOTT, b.1934, trained as a painter (R.A. schools) and did commissioned portraits and murals for some years. She started printmaking later, initially with lino and etching, more recently with wood engraving. She has had twelve solo shows since the early 1970s and has taken part in numerous mixed exhibitions in the U.K. and abroad. She has been a member of the Printmakers' Council, chairman of Gainsborough's House Print Workshop 1979–82, and has illustrated books for, among others, Michael Joseph, Faber, Macmillan and Penguin.

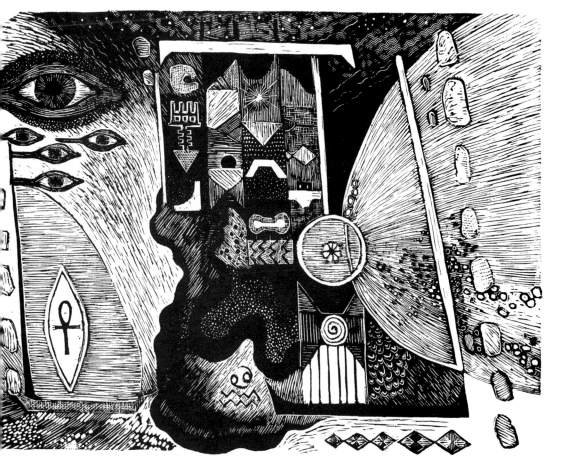

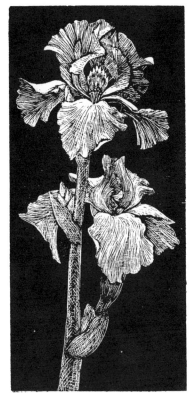

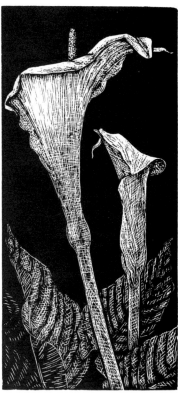

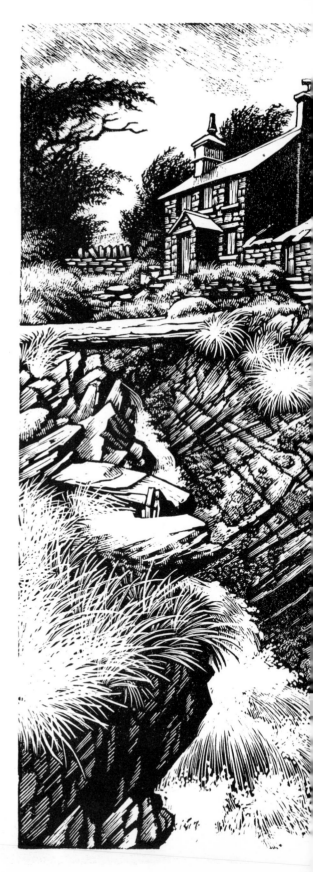

JOHN HOWSON, b.1934, studied at Northampton and later at the Royal College under Bawden, Nash and Stone. From 1964, he was lecturer in printmaking and associated studies at South East Essex College of Arts. He also pursued a limited career as a printmaker: colour linocuts, engravings and etchings; exhibiting throughout the U.K. (mostly in East Anglia) and abroad. In 1991 he took early retirement to concentrate on this work, mostly about the landscape and man's mark on it, particularly in the mountainous terrain of Wales and Cumbria. The print is reduced to 85%.

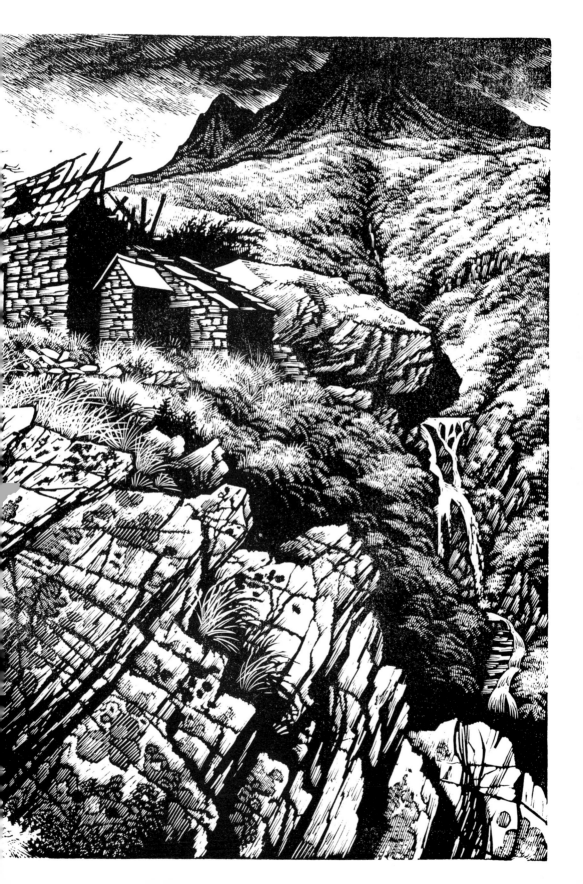

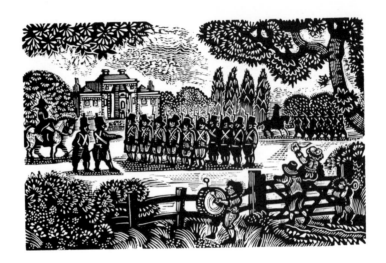

JOHN LAWRENCE, b.1933, is one of the country's most prolific and most appealing illustrators, in a variety of media. He learned his engraving from Gertrude Hermes at an evening class at the Central and all the engraving he has done has grown out of his book illustration or ephermeral commissions – with spectacular exceptions like *Rabbit and Pork: Rhyming Talk* which was his own idea. He aims to achieve a richness of texture and a fairly free engraving style, and prefers to be lighthearted where he can.

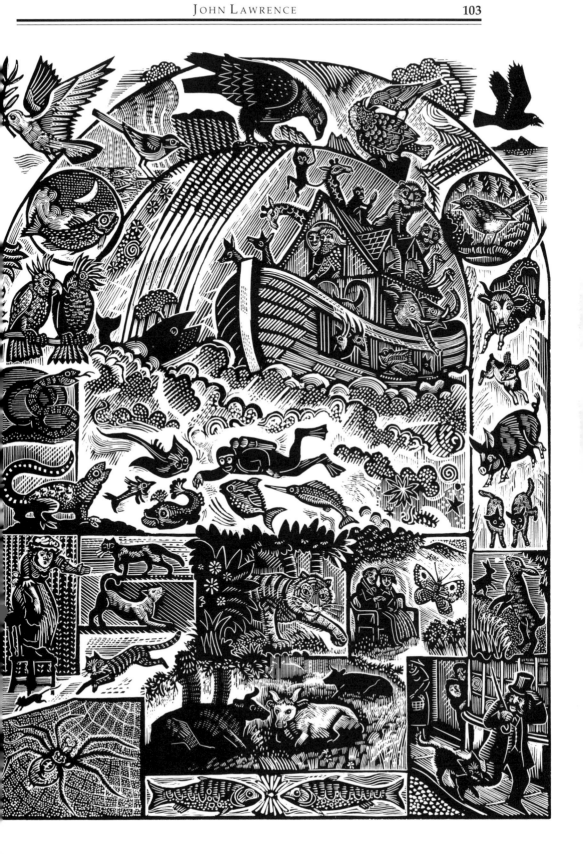

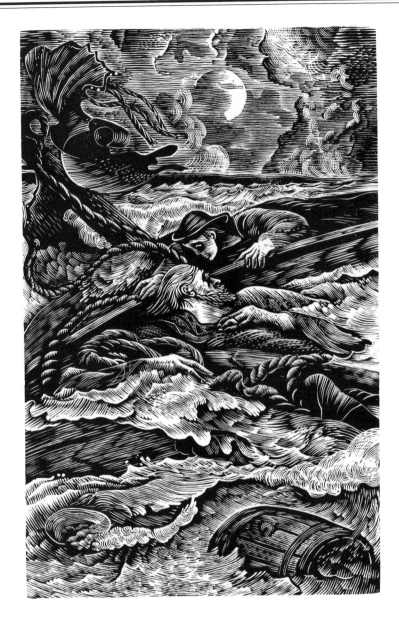

GEORGE TUTE, b.1933, another of Gertrude Hermes' students, was Principal Lecturer in Graphic Design at Bristol 1962–87 while simultaneously pursuing a busy career of exhibitions and commissions as painter, illustrator and wood engraver. He was also the first chairman of the resurrected Society of Wood Engravers. Within its apparently narrow restrictions of material and technique, he finds engraving capable of infinitisimal variations of expression and style, limited only by the imagination of the artist; its potential has still to be shown, although the best examples of the past will take some beating.

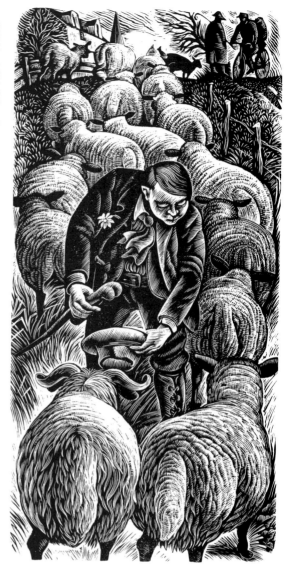

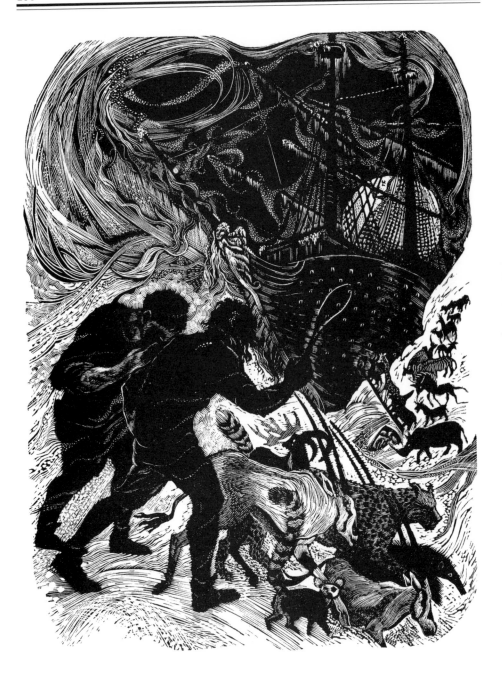

SHIRLEY MUNGAPEN, b.1933, painter, engraver and writer, has worked as an art therapist for many years and became a lay pastor in 1983. She was one of Gerry Tucker's students at Portsmouth. She sees artists' lives as being enriched by their visual experience and believes they sometimes have their fingers on the pulse of humanity. In wood engraving, these visual experiences, allied to a standard of craftsmanship, offer a balance of the practical and the inspirational in which she is happy to be involved.

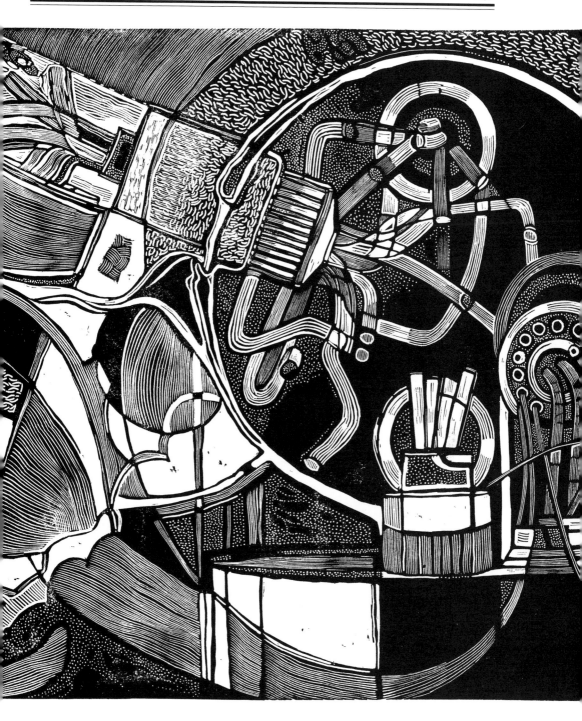

GARRICK PALMER, b.1933, retired from teaching at Winchester in 1986 and from the Society of Wood Engravers more recently, and is working full-time at illustration, engraving and photography. His prints and books with his illustrations published by The Folio Society and The Imprint Society of Massachusetts are landmarks for many.

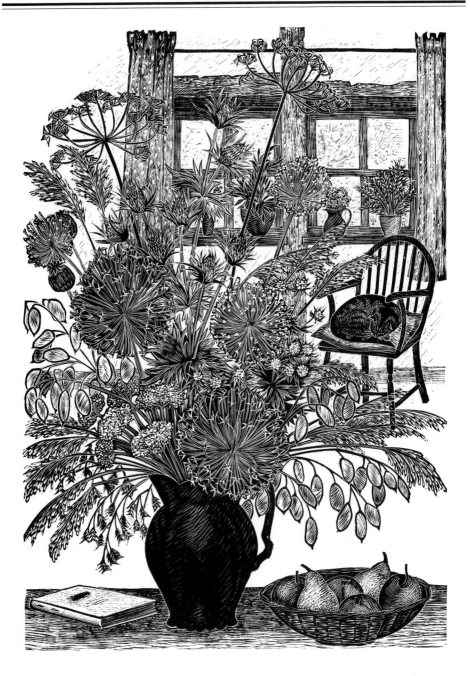

YVONNE SKARGON, b.1931, is an illustrator whose watercolours, drawings and wood engravings, often on botanical and culinary themes, have been commissioned by many leading book, magazine and journal publishers. She studied wood engraving with Blair Hughes-Stanton and John O'Connor and herself taught wood engraving at the Royal College of Art. Two books on her cats have been published, *The Importance of being Oscar*, 1988, and *Lily and Hodge and Dr. Johnson*, 1991. In 1991 she designed and engraved the Royal Mail commemorative issue of Roses postage stamps.

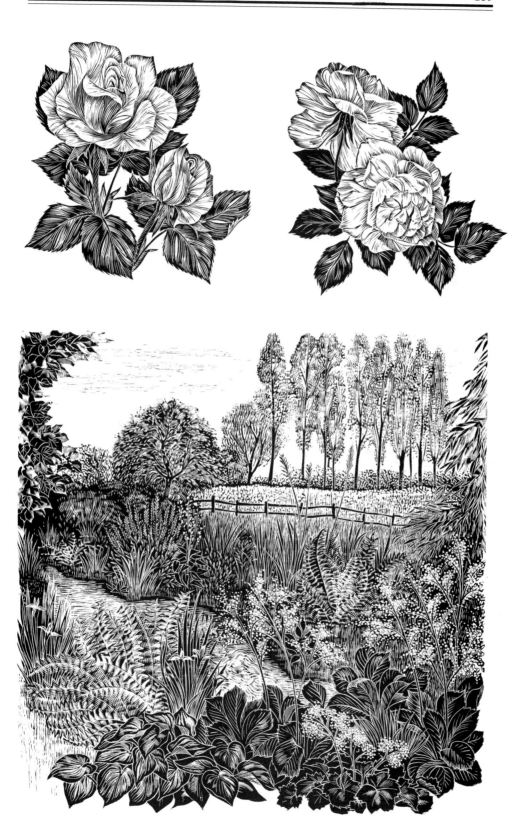

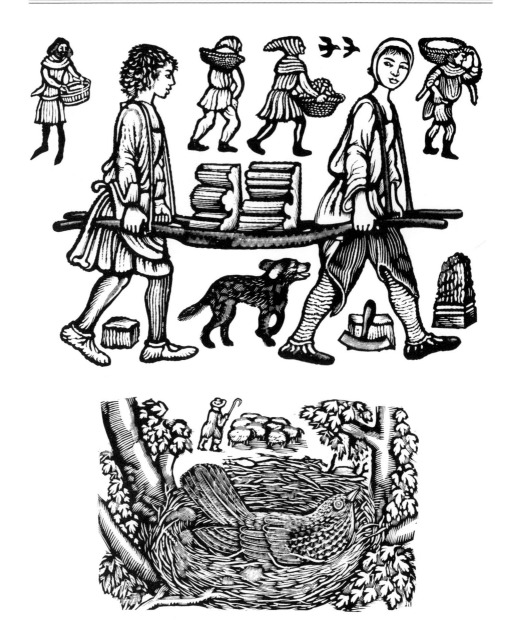

DAVID GENTLEMAN, b.1930, one of the few illustrators to achieve star billing (*David Gentleman's Britain*, 1982, *David Gentleman's London*, 1985) feels the conventional divide between painting and graphic design to be more academic than real. He was first inspired as an engraver by Bewick and Ravilious and studied under John Nash and Reynolds Stone at the Royal College. In work which ranges from postage stamps (1962 onwards) to the platform-length murals at Charing Cross Underground Station he has influentially taken engraving off the printed page, as well as using it in books, covers and advertising. All his engraving has been commissioned.

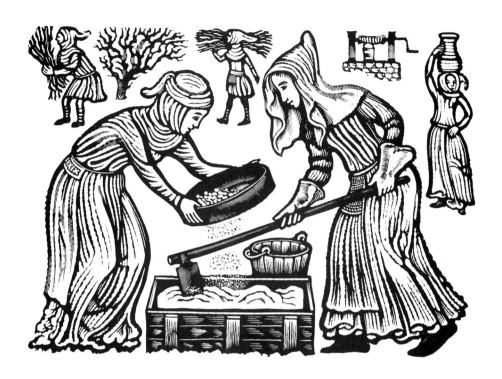

BETTY PENNEL, b.1930, was at the Royal College from 1949–52 and learned engraving from John Nash and Edward Bawden. From 1959–64 she taught at Birmingham College of Art and since then has had her own studio as a painter and engraver in Herefordshire. As a painter, she uses engraving as an alternative means to express her feeling for English gardens and the countryside. She began engraving on wood and metal but now works on plastics of various kinds.

Monica Poole
Peter Reddick

4

The distinction between generations seems to break down. Monica Poole's print is Winter, but the fourth season of an artist's life, God willing, is Indian summer. If Frank Martin does less engraving now, it is simply because he is busy with other things and his interests have moved on; the quality of his engraved work and his support for the medium remain an inspiration. Peter Reddick, who was Gregynog Arts Fellow in 1979–80, is one of the best examples of the approach to engraving described in the previous section; Reg Boulton, in the large and spectacular engravings he makes on plastic – too large for this book – is another.

To separate these four from the previous group when some belong there stylistically and all are together reaping the harvest of fifty-plus years, is to recognise not just a further ten or fifteen year difference in age, but the difference in numbers too and the significance of the gap between: these are facts of history. Anyone born between Peter Reddick (1924) and David Gentleman (1930) who might have been an engraver, wasn't. To be adult or grow up straight into a major war is a profoundly different experience from growing up during or after it. And the second major hiatus in engraving, the withdrawal of teaching (that is, of confidence in a future) occurred as they approached fifty. There were no celebrations but only, apparently, a closing-down.

The achievement of these four and their contemporaries is, in that context, the more remarkable, but especially that of Monica Poole.

Almost alone among the artists in this book, she has kept faith with wood engraving as the independent, original print. Though, as a younger woman, she did her share of illustrational work, she has concentrated more and more exclusively on a visual art which does not illustrate another, verbal idea, but which tells its own truth. Of course, many engravers – Hilary Paynter, Betty Pennell, Sarah van Niekerk, too many to list – make independent prints, but most are involved in illustration too, for employment and to make their reputations. And, of course, engraving is ideally suited, it is part of its history, to appear as the handmaiden of literature. Monica Poole has chosen otherwise, to be the mistress of her own vision, to risk the less frequent exposure and insecure rewards of exhibitions and to rest her case, classically, on her art, as an engraver on wood. It is a singular and radiant example.

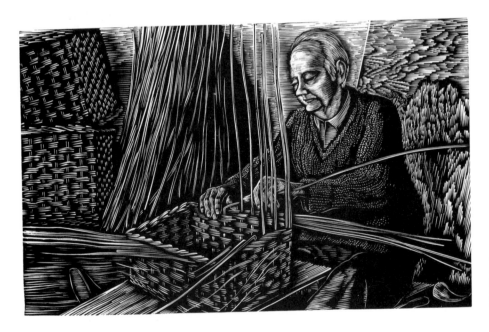

PETER REDDICK, b.1924, works as a book illustrator, mainly using wood engravings. He also takes on work for advertising, occasionally. He has illustrated books for the Folio Society, the Gregynog Press, Collins, Dorling Kindersley, The Limited Editions Club of New York and The Readers Digest and his other fields of work include watercolours and colour woodcuts. He exhibits with the Royal Society of Painter Etchers and the Royal West of England Academy.

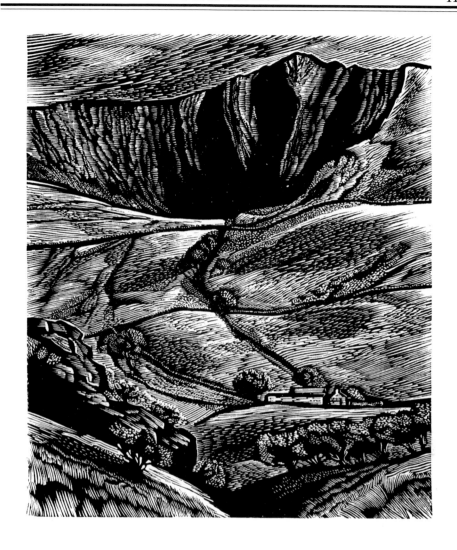

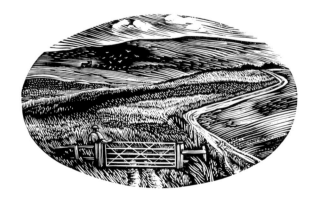

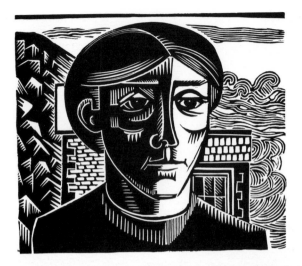

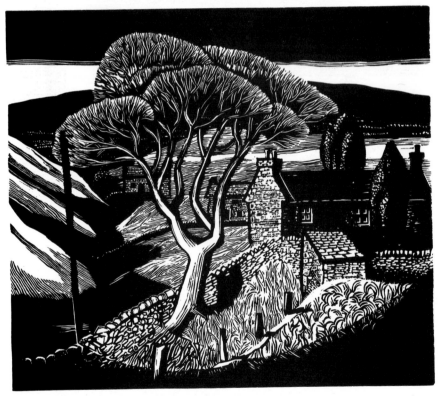

REG BOULTON, b.1924, trained as a teacher, after service in the R.A.F. and taught art at Huntingdon Grammar School for ten years, engraving illustrations for the Vine Press meanwhile. For eighteen years he taught at Colleges of Education in Yorkshire and Hereford and returned to engraving on early retirement. He is mainly interested in design problems and especially likes working with books and with type or lettering. He cuts lettering in slate and engraves in metal. He has also been active in organising national and international exhibitions of wood engraving.

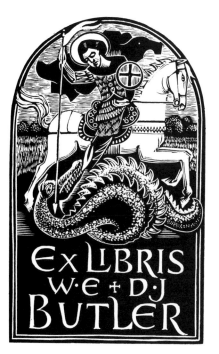

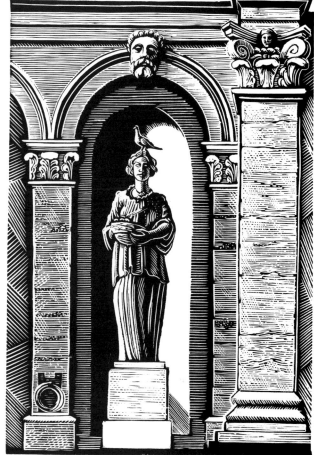

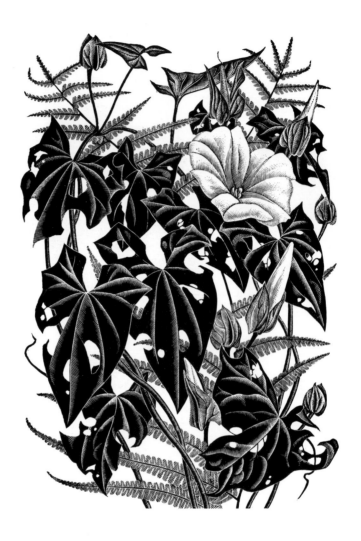

MONICA POOLE, b.1921, studied with John Farleigh on the Book Production course at the Central School 1946–49. Her own book on *The Wood Engravings of John Farleigh* was published in 1985, while *Monica Poole – Wood Engraver*, with a text by George mackley, appeared in 1984. Her list of exhibitions contains many contributions to shows of engraving and on botanical themes, in Europe and in the U.S.A. She tends to engrave rather stark subjects at one time and gentler landscapes at another; on the whole she is more interested in the former.

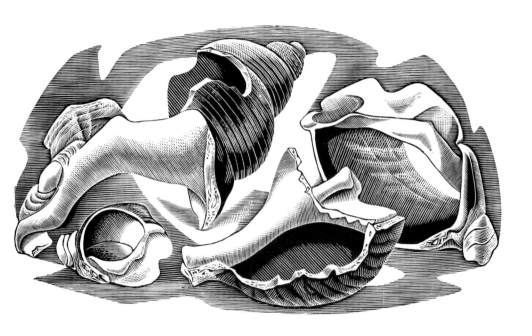

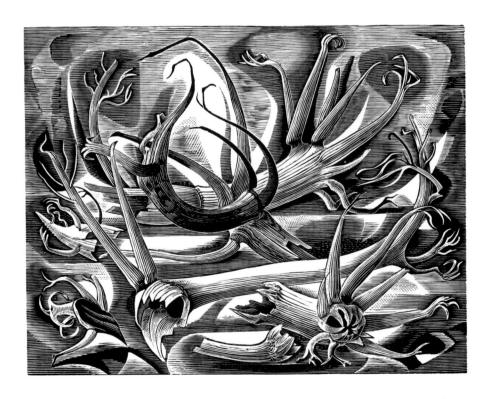

FRANK MARTIN, b.1921, studied with Gertrude Hermes at St. Martin's. Between 1948 and 1966 he worked as a freelance illustrator and wood engraver, for numerous book and magazine publishers, advertisers and private clients. Since 1966, he has been primarily a printmaker in woodcut, etching and drypoint. Between 1953 and 1980 he taught engraving and etching at Camberwell, from 1976 as Head of Graphic Arts. he has had sixteen one-man exhibitions, in the U.K. and abroad, since 1956.

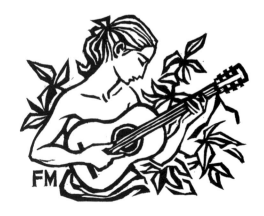

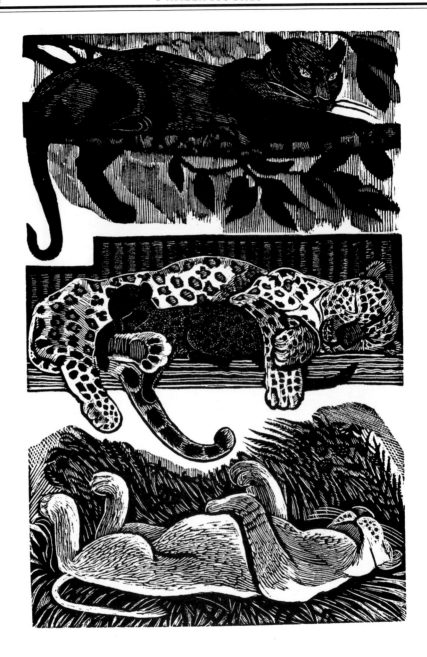

PAMELA HUGHES, b.1918, was a student at the Central School, specialising in stage design, and learned wood engraving after the war from James Osborne, at the Regent Street Polytechnic. She has practised most forms of printmaking and appreciates the directness of wood engraving by comparison. She has exhibited widely and regularly since the early sixties, nationally but especially in East Anglia, where she has illustrated books for the Golden Head Press and played an important part in the prestigious Cambridge Drawing Society.

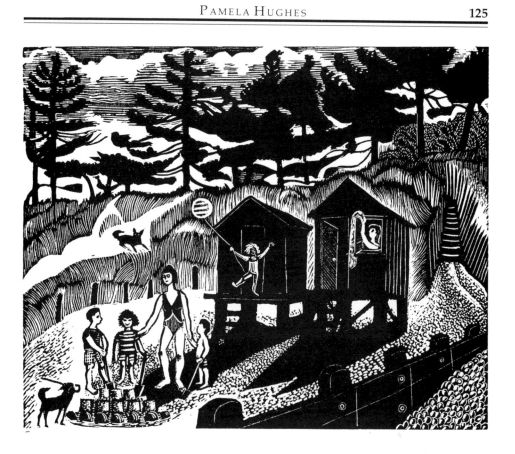

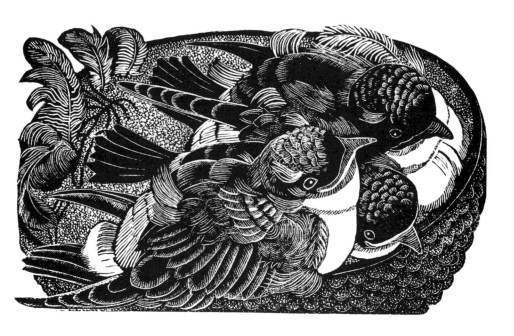

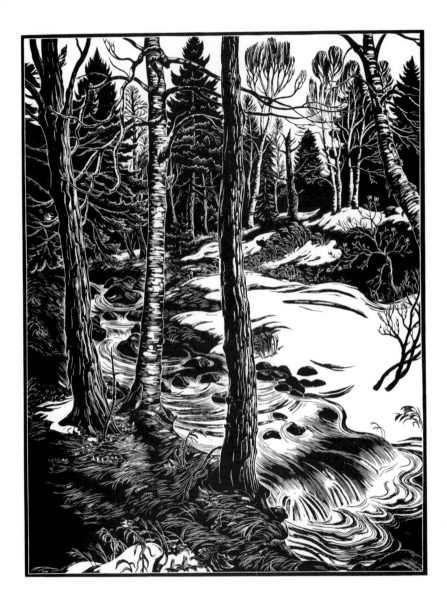

HERBERT WATERS, b.1903 in Shantou, China, attended high school in Shanghai and university in America, graduating in 1926. He then studied art in Pennsylvania and at the Chicago Art Institute. Since 1933 he has lived on the edge of the White Mountains in New Hampshire, practising his art and teaching, for the W.P.A. in the 1930s and at the University of New Hampshire, Holderness School in Plymouth and at Alderson-Broaddus College in Philippi, West Virginia; from the last two, he holds honorary doctorates. His work is in many State and national collections. Both prints are reduced to about 75%.

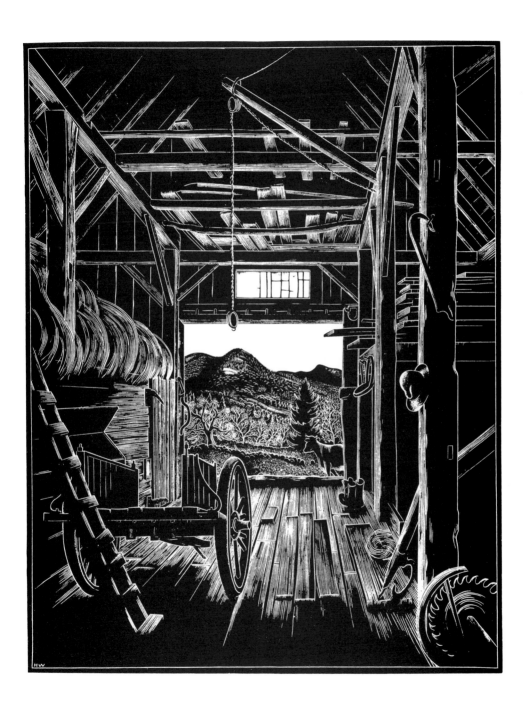

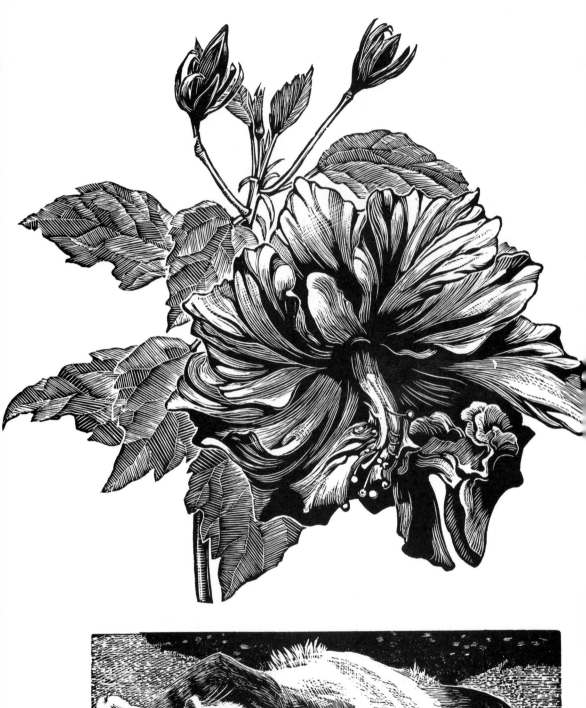
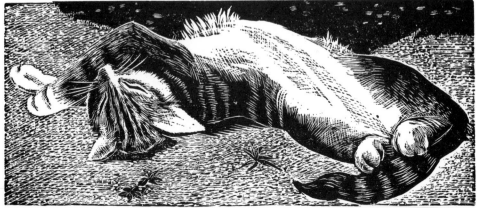

CODA

Not all the members of the Society of Wood Engravers have chosen to be represented in this book. In particular, older artists have generously made way for the young. William Rawlinson and Sybella Stiles (b.1912) may stand for many in their own generation and beyond. They exhibit regularly with the Society and find ready buyers. Together with Enid Marx (b.1902) they provide a living and active continuation of an enthusiasm which they themselves inherited and which we trust we will be able to pass on. Wood engravers know themselves to be rare enough creatures for there to be no professional rivalry between artists or between generations, but rather a genuine fostering of the continuation of the art.

Among those who share this enthusiasm are artists who are not or are not yet members of the Society, whether because they have not done enough work or have not reached an appropriate degree of artistic maturity, or simply because they have not chosen to apply. A selection of their work provides a fitting coda and, again, is chronologically arranged.

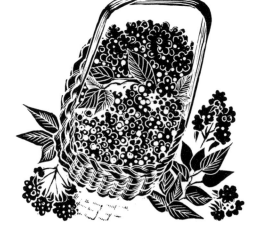

Opposite: William Rawlinson
 Sybella Stiles
This page: Enid Marx

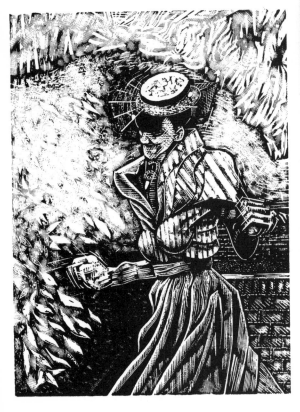

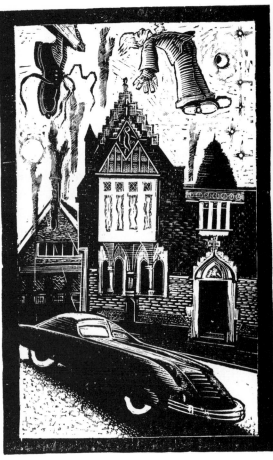

COLIN KENNEDY, b.1960, takes the imagery for his engravings mainly from related paintings and drawings; many are colour prints: this is exhibition work. He also does commissioned illustration and design work. He studied at Newcastle but learned about wood engraving from a friend.

CLARE HEMSTOCK, b.1959, took a BA in graphic design at Norwich 1979–82 and an MA at the Royal College 1983–86, where she learned engraving from Yvonne Skargon. She now works full-time as a wood engraver from a studio in Stamford, Lincs.

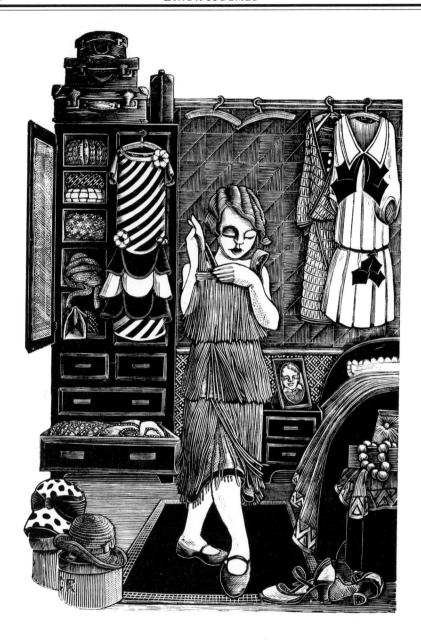

LINDA HOLMES, b.1950, discovered
engraving at Camberwell in 1989 under
John Lawrence and Simon Brett, while
still pursuing a career in B.B.C.
journalism. Without formal art training –
just a life-long habit of drawing – but
with neighbourly advice from Yvonne
Skargon, she has now taken to it full time
and completed a first commission.

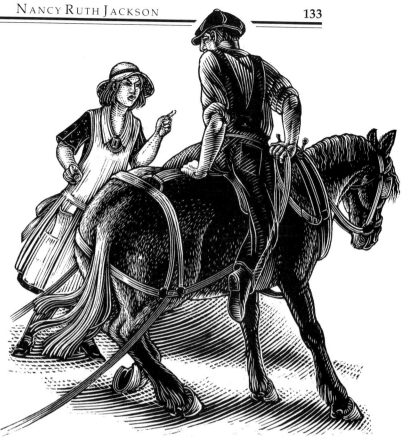

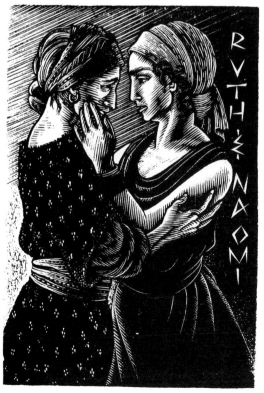

NANCY RUTH JACKSON, b.1952, is a full-time illustrator and book designer in Toronto. Engraving accounts for about a quarter of her work and was originally encountered through the seed catalogues on her uncle's farm and Eric Gill's *Four Gospels*. She learned how to make and handle tools from a retired metal engraver, and trial and error did the rest.

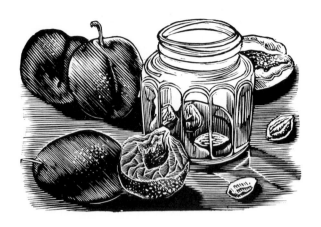

CHRIS DAUNT, b.1957, trained in fine art at Newcastle, read English Literature at Newcastle University, taught it at Gdansk University and had tried to be a Cistercian monk. He is now a full-time freelance artist, mainly in copper and wood engraving, in which he is entirely self-taught. Recent commissions have been for Shell, *The Independent on Sunday* and The Folio Society.

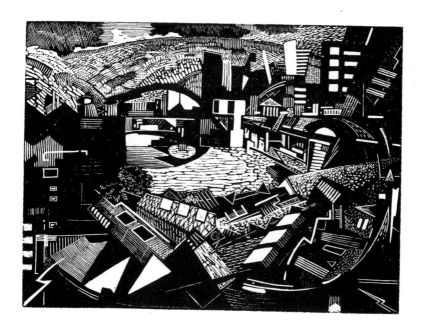

ROY WILLINGHAM, b.1957, studied painting and printmaking at the Central School but was only taught wood engraving subsequently by a fellow-student, Willow Winston. He is a full-time artist by intention, a part-time one by necessity at present. Wood engraving is one process among many, which are interdependent.

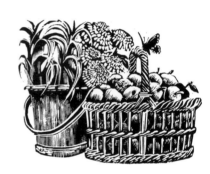

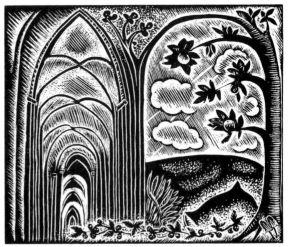

ANGELA LEMAIRE, b.1944, studied at Chelsea and Camberwell schools of art. She is an artist (painting and relief print) who sometimes uses wood engraving, in which she is self-taught; and a writer: one published novel to date.

CHRISTOPHER CUNLIFFE, b.1944, studied illustration at Carlisle and works as a printer and wood engraver: prints sell in limited editions all over the country – even in London. Available to commission. But slow, or so he says.

LLEWELLYN THOMAS, b.1958, trained at City and Guilds and the Royal College, learned engraving from Sarah van Niekerk, is a full-time artist-illustrator, often using engraving or woodcut, and a lecturer in illustration at Maidstone.

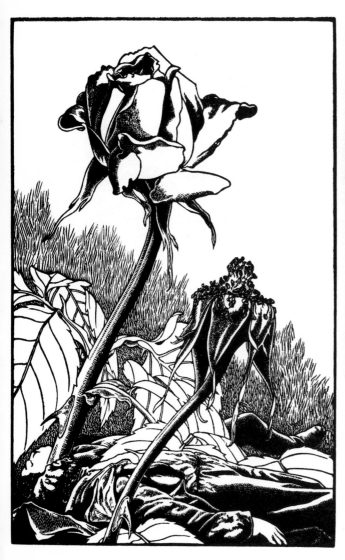
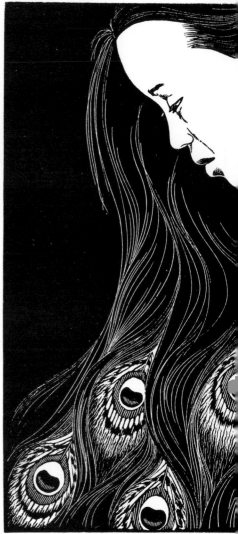

ABIGAIL RORER, b.1949, studied printmaking at the Rhode Island School of Design and is a full-time artist who sometimes uses wood engraving but is increasingly drawn to it. Attracted by 15th and 16th century and German Expressionist woodcuts, she got a few words of advice from Barry Moser in 1977 and then practised alone until she figured it out.

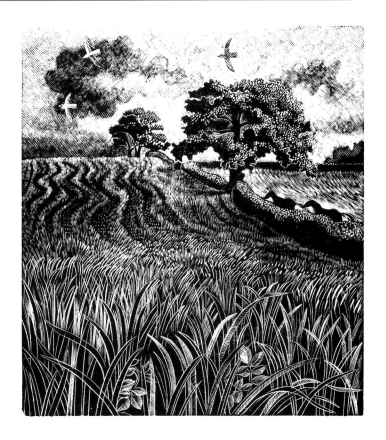

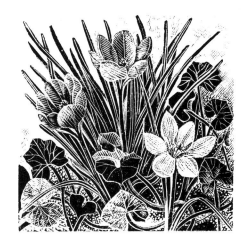

ANNE HAYWARD, b.1941, was at Southampton and St. Martin's School of Art, learning printmaking at the first and painting at the second, but only discovered wood engraving in the 1970s, gradually becoming involved in it to the exclusion of other forms of printmaking. From 1989, sales of prints encouraged her to give up teaching. Wood engraving now occupies more time than painting.

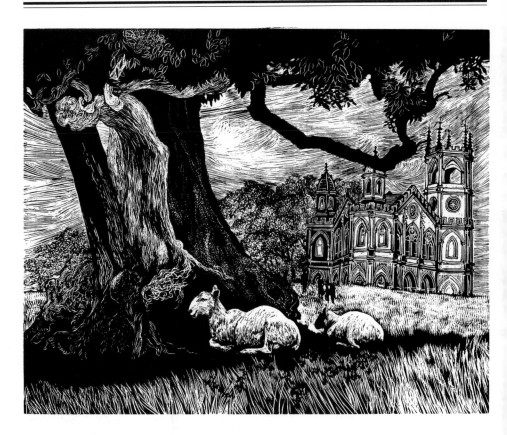

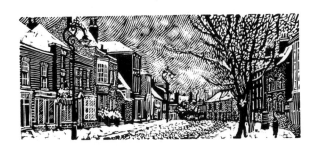

ANN TOUT, b.1941, was taught engraving by Elizabeth Nolan. In the early 1960s she worked as a freelance book illustrator and part-time tutor at Bournemouth College of Art. She now works as an engraver, watercolourist and bookbinder, and has returned to teaching, taking classes in printmaking and in painting.

WILLIAM FULLJAMES, b.1939, studied sculpture and wood engraving at Portsmouth under Gerry Tucker. He built himself a studio on Ibiza and has lived there for twenty years mainly making sculpture; but he likes also to produce a fair number of prints every year. The detail above loses no more than an inch on each side of the image.

PAM PEBWORTH, b.1931, trained as an art and craft teacher at Corsham in the 1950s and worked in secondary education for twenty years. She came late to wood engraving, in 1988, but has brought her own lifetime's experience to Sarah van Niekerk's tuition at West Dean. She has exhibited regularly and throughout the 1980s has had work accepted by the Royal West of England Academy.

INDEX including captions and acknowledgements